YESHIVA UNIVERSITY
MUSEUM

THE ART OF AGING

**Hebrew Union College-
Jewish Institute of Religion
Museum - New York**

**The American Jewish
Joint Distribution
Committee**

JDC-ESHEL – The Association for
the Planning and Development
of Services for the Aged in Israel

UJA-Federation of New York

Essays by
Laura Kruger
Ayana Friedman
and Yitzhak Brick

Edited by
Jean Bloch Rosensaft
and Tuvia Mendelson

Published in conjunction with the exhibition **The Art of Aging** Hebrew Union College-Jewish Institute of Religion Museum September 2, 2003- June 25, 2004

Organized by the Hebrew Union College-Jewish Institute of Religion Museum and the American Jewish Joint Distribution Committee (JDC) and JDC-Eshel – The Association for the Planning and Development of Services for the Aged in Israel.

We gratefully acknowledge the generous support of **UJA-Federation of New York** for the publication of this exhibition catalog.

John Ruskay, *Executive Vice President & CEO*
Alisa Rubin Kurshan, *Vice President, Strategic Planning & Organizational Resources*
Cheryl Fishbein, *Chair, Caring Commission*
Martin R. Gold, *Chair, Task Force on Aging, Caring Commission*
Roberta Leiner, *Managing Director, Caring Commission*
Robert Wolf, *Executive Director, Medical and Geriatric Programs*
Alan Cohen, *Director of Planning and Program Development, Caring Commission*

JDC-American Jewish Joint Distribution Committee
Nadine Habousha, *Assistant Executive VP for International Relations*
Claire Schultz, *Assistant Executive VP for Marketing & Communications*
Allan DeYoung, *Director of Communications*
Vicky Mevorach, *Director of Israel Desk*
Annette Flaster, *Creative Director*

JDC-Eshel
Dr. Zvi Feine, *Chairman of the Board*
Dr. Yitzhak Brick, *Director General*
Tuvia Mendelson, *Director of Publications*

Shlomi Amsallem, *Catalogue Design, Studio Aleph*
Ayana Friedman, *Curator JDC-Eshel's Artists*

Hebrew Union College – Jewish Institute of Religion Museum
Jean Bloch Rosensaft, *Director*
Laura Kruger, *Curator*
Reva Godlove Kirschberg z"l, *Registrar; Docent Coordinator*
Ruth Friedman, *Museum Coordinator*
Sarah Schriever, *Public Programs Coordinator*
David Golan, Hilla Israeli, Julian Mintzis, Orit Ryba, Ora Warmflash, *Interns*

Printed in Israel in 2003 by **JDC-Eshel** P.O.Box 3489 Jerusalem 91034, Israel www.eshelnet.org.il

Hebrew Union College-Jewish Institute of Religion Museum Brookdale Center One West 4th St. New York, NY 10012-1186 www.huc.edu/museums/ny

LIBRARY OF CONGRESS CATALOGING-IN-PUBLICATION ISBN 1-884300-06-5

The Art of Aging

In loving tribute to

Reva Godlove Kirschberg ז״ל
(1921-2003)
founder of the Hebrew Union College –
Jewish Institute of Religion Museum,
whose love for Jewish art, culture, and
heritage endures as a precious legacy

**HEBREW UNION COLLEGE-
JEWISH INSTITUTE OF RELIGION,**
founded in 1875, is the nation's oldest
institution of higher Jewish education
and the academic and professional
leadership development center of
Reform Judaism. HUC-JIR educates men
and women for service to American and
world Jewry as rabbis, cantors,
educators, and communal professionals,
and offers graduate and postgraduate
programs for scholars of all faiths. With
centers of learning in Cincinnati,
Jerusalem, Los Angeles, and New York,
HUC-JIR's research resources comprise
renowned libraries, archives, and
museums, biblical archaeology
excavations, and academic publications.
HUC-JIR invites the community to an
array of cultural and educational
programs that illuminate Jewish history,
identity, and contemporary creativity
and foster interfaith and multi-ethnic
understanding.

**JDC - THE AMERICAN JEWISH
JOINT DISTRIBUTION COMITTEE**
is the active, on-the-ground expert
reaching out to Jewish communities in
distress and working to enhance Jewish
lives and Jewish life in Israel and around
the world. Since 1914,
JDC has brought care, compassion and
help to millions, and it has had a
presence at one time or another in over
85 countries.

**JDC-ESHEL – THE ASSOCIATION
FOR THE PLANNING AND DEVELOPMENT
OF SERVICES FOR THE AGED IN ISRAEL**
is a partnership of JDC and a consortium
of Israeli government ministries. JDC-
ESHEL is the leader in developing
services and facilities for all elderly
Israelis; it helps veteran Israelis as well
as the most recent immigrants, Jews as
well as Arabs.

UJA-FEDERATION OF NEW YORK
is the largest local philanthropy in the
world, dedicated to caring for those in
need, strengthening Jewish peoplehood,
and fostering Jewish renaissance in New
York, in Israel, and in 60 countries
around the globe. We offer a safety net
of help – and hope – through an
interconnected network of more than
100 human-service agencies, each with
dozens, even hundreds, of targeted
humanitarian programs. Our efforts
touch more than 4.5 million lives every
year, creating a true "community of
caring" – one that reaches out from
greater New York and stretches back
more than five thousand years.

The Hebrew Union College-Jewish Institute of Religion Museum is honored to present **The Art of Aging**. This exhibition represents a dynamic partnership between our institution and the American Jewish Joint Distribution Committee (JDC) and JDC-Eshel The Association for the Planning and Development of Services for the Aged in Israel, with the generous support of UJA-Federation of New York. Moreover, it symbolizes the shared values and commitments of Israeli and North America Jewry in affirming the vitality of the human spirit.

The Art of Aging was inspired by an exhibition, **Golden Aging – The Third Color**, organized by Tuvia Mendelson and Ayana Friedman and presented in Jerusalem in 2000. With the addition of artists from North America and England, we have amplified the dialogue in the context of the significant demographic shifts in our increasingly aging Jewish populations. Our goal is to engage the larger community in reflecting on the Jewish values attendant to the aging process and in finding meaning in the universal aspects of life's journey as it impacts on each of our own lives, our families, our communities, and the Jewish people.

Aging is a process that begins with birth – it is a lifelong journey affecting the dynamics of human relationships, creativity, memory, continuity, and growth. Jewish text sources are full of references to values intrinsic to the aging process; respect for one's elders, honor for one's parents, forty as the age of understanding, fifty as the age of counsel, the celebration of wisdom at age sixty, the celebration of strength at the age of eighty, and intergenerational and familial responsibilities.

Through painting, sculpture, photography, installation, fiber, mixed media, and video, these contemporary artists from Israel, England, and North America invite us to explore the diverse aspects of aging, including creativity and vitality, memory, anxiety, wisdom, physical change, loss, intergenerational interaction, responsibility, and optimism.

Such issues of contemporary identity lie at the heart of our Museum's mission – to present the creativity of artists of all faiths exploring Jewish identity, history, and

experience. In encouraging contemporary artists to illuminate issues of faith and culture, our hope is to foster a deeper appreciation of Jewish heritage, to build bridges of multi-ethnic and interfaith understanding, and to transmit that consciousness to present day and future generations.

In *Kohelet* we read, "All streams flow into the sea, yet the sea is never full; To the place from which they flow, the streams flow back again." (Ecclesiastes 1:7) **The Art of Aging** demonstrates the seamless confluence of the Jewish past, present, and future and expresses our hopes for life, renewal, and redemption.

Jean Bloch Rosensaft
Director
Hebrew Union College-Jewish Institute of Religion Museum

Most Israelis over the age of 65 are independent and have no trouble functioning on a daily basis. Over 80% of Israelis aged 65 or over lead independent lives; about 10% of this age group continue to work, and another 10% are involved in volunteer activites. The vast majority of all the others continue to enjoy an active life in every respect – recreation, outdoor life, theater, art, friends and family, reading, hobbies, and the like.

According to Cicero, the Greek philosopher and politician, old age is a stage of life that relates not only to loss, but also contains opportunities for positive change, for fertile and creative activity, and for rewarding growth.

The image prevalent in Israel, however, is that of a feeble old person with limited and minimal functioning who is no longer a creative, contributing member of society. This illusion must be challenged. How? One way is by giving widespread exposure to the work of elderly artists. This will present the public with the contemporary reality of elderly people who have intellectual and creativity talent, and whose contribution to society and culture is no less valid than that of young people.

The naïve artist Anna Mary Moses, known as Grandma Moses, engaged in embroidery for many years. At the age of 78, when her fingers lost their nimbleness for embroidery, she tried her hand at oil paintings. Her gaily-colored paintings of rural America soon appeared in international exhibitions. In 1960, at the age of one hundred, Moses illustrated an edition of "It was the night before Christmas."

Such examples can also be found in Israel: Hannah Shmuelian, an immigrant to Israel from Rafsanjan in southern Persia, began to paint at the age of 70, drawing scenes from folk tales and her childhood memories. Hannah's works were exhibited in Jerusalem and her sons subsequently organized an exhibit of her works in New York, which met with success. Painting is Hannah's primary form of expression, as she is illiterate.

My father, may he rest in peace, was a building contractor. Like others of his generation, he began as a construction worker who slowly made his way up the professional ranks and eventually became a building contractor in Jerusalem. At the age of 70, he decided to retire and took up reading, study, and writing. For some twenty years, from age 70

to 90, he wrote two books and published fifteen articles in academic journals in his field of interest: historical-rabbinical research. Not only did my father's intellectual and mental powers not diminish, they grew and improved during these years.

Successful and creative old age is therefore definitely in the realm of the possible. Research by Rowe and Kahn, published in the United States in 1988, cites three characteristics of successful old age: the absence or limited nature of illness or disability; a high level of physical and mental ability; an active life. This third feature is the most important, because an active, creative life makes a good old age possible, even when good health and functioning diminish. The elderly are the primary beneficiaries of this creativity, which enhances self-image, improves one's sense of well-being, and contributes to general good functioning.

Acknowledgment of older artists in society can contribute to changing the image of the elderly and undermining the stereotypical perceptions. When we are in the presence of the art of an adult – an author, playwright, musician, artist, sculptor, or actor – we do not judge the work by the artist's age, but according to its artistic value. While one must not ignore the chronological dimension in defining old age, this dimension alone does not exhaust all the qualities of old age and its impact.

Ever since its establishment in 1969 by the Government of Israel and the American Jewish Joint Distribution Committee (JDC), JDC-ESHEL has been developing innovative programs and services aimed to ensure the well-being of the elderly in Israel. In this context we foster and encourage any form and expression of creativity among the elderly as a vital means of improving their personal satisfaction and quality of life.

DR. YITZHAK BRICK
DIRECTOR-GENERAL, JDC-ESHEL

It is through the eyes of creative artists that we are able to mirror ourselves. Translating their own concerns, fears, and jubilations through exquisite technical skills we are gifted with insights to view the future and review the past.

The Art of Aging, a fine arts exhibition, celebrates the positive aspects of maturity through the lens of Jewish values. Through study, *tzedakah*/acts of charity, and positive family relationships, aging is a remarkable opportunity for continued creative growth. At the age of 53 one celebrates the 40th anniversary of *Bar* and *Bat Mitzvah* with renewed insights, *Simchat Hochmah* is a ceremony that recognizes wisdom at the age of 60, *Simchat Gevurah,* at 80 years, acknowledges strength and vigor.

The Art of Aging focuses on the fact that aging is a continuum, changing from hour to hour, day to day, year to year. It includes the view of young artists experiencing the first recognition of this transformation. It includes metaphors for the moments that are too emotional to visualize. It includes the exuberance and zest that maturity affords us. It includes the many aspects of long memories and the subtle, tragic diminutions of memory. It balances anxiety and loss of control with wisdom, continuity, and generous relationships. It offers creativity and choice as the antidote to forced redundancy and loneliness.

We view, through the artist's vision, death as an evolving process, a slow decline. Sorrow is mitigated by memory; images of fading nature, darkness falling, and clouds gathering convey the melancholy reflections of a once vibrant life. Each of the works in this exhibition captures the vibrancy of life lived to its fullest, even as it seemingly slows down. As the body ages it changes and records long life with the rich topography of engraved lines, furrows, folds, wrinkles, and creases. Artists revel in the complexity of texture, seeing in skin surface the marks of human events. These lines become abstractions of the drama of life.

Humor is, of course, the cushion to ease the vicissitudes of aging. Jewish humorists and, in this special instance, Jewish cartoonists, cut clear through the essence of aging angst. Why don't the children stay in touch, what happened to my virility, do you love me for myself or my accrued assets

– the perfect astringent for maudlin thoughts. Each cartoonist in this exhibition is not only a philosopher but also a brilliant draughtsman who, with economy and dispatch, illuminates a despairing social situation.

How we see ourselves at differing points on the arc of life is frequently determined by the vision of fine artists sharing their pasts or looking into the future for us. Their observations translate personal events into universal themes.

Laura Kruger
Curator
Hebrew Union College- Jewish Institute of Religion Museum

The Art of Aging

A pitched battle is being waged in the mass media against the forces of nature, especially aging. Medical businesses and corporations have used the media to promote weapons against wrinkles, vitamin supplements, enhancement therapies, specialized exercises, plastic surgery, and more. And the subtext of these messages is that someone who looks old is indeed old, and has thereby lost his or her place in the world of the young, i.e., the world of those beautiful, active and involved in society.

Concern for the elderly appears in the Biblical Ten Commandments: "that your days may be long in the land." Obeying this commandment, notes the Bible, is a worthy example to future generations. In Psalm 71, the supplication is "Do not cast me off in the time of old age; forsake me not when my strength is spent" – the recurring phrase intended to emphasize that the elderly should remain within the family and have a place of honor even when he or she is no longer "useful." While the supplication is addressed to God, it is a message beyond the individual, a moral and emotional message aimed at the family and society.

What are the faces of aging, as presented in the works of contemporary Israeli artists? How do they reflect aspects of aging in contemporary Israeli society?

The work shown here depicts several aspects of aging, and the more the outer shell of aging is described, the more these depictions manage to broaden their scope. These works convey not just the characteristic outer appearance of the elderly – the worn face and body, the changes in posture and movement – but they focus on the circumstances of being old much more than outward appearances.

One characteristic facet in depicting the appearance of the elderly, which accompanies the bent back and thinning white hair, is the change in activity and movement. Most elderly people appear as passive figures – sitting on a bench, staring off into space, waiting, just looking. Seen in action, they appear hesitant, unconfident, and particularly cautious as in Sergei Teryaev's "The Golf Player."
Another particularly salient facet depicts inter-generational relations: an old person juxtaposed with youth, or society and the family in counterpoint with an elderly person. Older artists are much more engaged by these relationships than with descriptions of

the wrinkles or gray hair of the elderly. Several works emphasize the isolation of the elderly from other parts of society, and indeed the elderly are a group unto themselves: They live in nursing homes or in sheltered housing, tend
to pass time together with other old people in the park, or participate in activity designed just for the elderly, such as exercise groups on the beach.

In general the elderly are not portrayed as part of a larger family or social context, nor in multigenerational or age-varied milieus. In "The Wait" and "The Bathers" by Ruth Schloss, for example, groups of old people appear with other old people only. "The Wait" is a hard look into a nursing home, where sick and lonely old women are locked into their own worlds, even when several share a room.

The works of Hava Raucher depict elderly women, with old kettles or other objects from the past beside them.

Some artists take a nostalgic look at figures from their grandparents' generation, depicting objects in a romantic light. This can be seen in the paintings of Itzhak Yamin and the photographs of Yehudit Matzkel. The subject is primarily a visual memory, and not necessarily testimony of a relationship between the younger and older generations.

In previous generations, images of the elderly were even more blatantly negative. Old women were portrayed as witches; to this day, an ugly old woman riding a broom is immediately perceived to be a witch. These qualities, taken from the standard catalogue of western cultural images, appear in the works of artists such as Hans Baldung-Grien and Goya. Generational characteristics were created in the unique symbol language of Norwegian artist Edvard Munch: the young girl is a pure figure in white; the mature woman is sexual, active and even a *femme fatale*, symbolized by red and sensuous body movements; and the old woman is an ugly, dried out and gnarled figure, wearing black and lacking all femininity.

Good looking, active older people, who maintain their previous activity – working, creating, loving and expressing their love, participating in sports and sex – arouse wonder and

amazement in many of us, as the elderly are not expected to engage in such "young" activities.

In the children's book *An Old Woman on a Swing*, author Tamar Adar describes a variety of society's attitudes toward the strange and deviant phenomenon of a woman in her eighties on a swing in a playground for her pleasure. Assorted passersby make snide remarks, from which we learn that this is not a proper activity for an old woman; she would be better off sitting at home and knitting for her grandchildren and great-grandchildren. The story also reflects a pervasive view: For old people, their time is past, and any activity connected in spirit to the young is an inappropriate invasion of territory not theirs.

In one of his works, Paul Fux depicts the scene in his white-haired head – a young couple passionately kissing. This composition expresses a feeling and experience that many older people repeatedly express: This aging body is inhabited by a young person, with real desires that are not reconciled to the aging shell, not in appearance and certainly not in keeping with social conventions.

In her film in this exhibit, the actress-dancer Devora Bertonov expresses many of the feelings of the older person. While dancing, she leaves her role as clown and passes on her props and the role itself to a young actor. The ritual of parting is difficult, but the transition must be and is indeed made, consciously and in a positive and celebratory gesture. The "brown leaf," notes Devora, makes way for the "green leaf."

AYANA FRIEDMAN
LECTURER
ART HISTORY AT THE ISRAEL MUSEUM AND A CURATOR

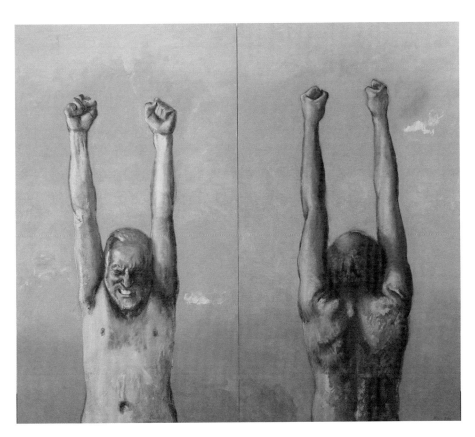

Who Can Forget How Blue the Sky Was Beforehand, 2001, oil on canvas, diptych, 60 x 34 in. each

SIGMUND ABELES | BROOKLYN, NY, 1934

Education: Columbia University, New York, M.F.A; University of South Carolina, B.A.

Selected Permanent Collections:
Fine Arts Museum of San Francisco; Whitney Museum of American Art, New York; British Museum, London; Museum of Modern Art, New York; Metropolitan Museum of Art, New York; Museum of Fine Arts, Boston

Selected Exhibitions: Portland Museum of Art, ME; Burroughs/Chapin Art Museum, Myrtle Beach, SC; Thomas Williams Fine Arts, London; Whistler Museum of Art, Lowell, MA; Boston Public Library

The content of my work is and has been the human condition as seen through my sensibilities. My best efforts document the gamut of images from birth to death and the many sweet and bitter moments in between.

RORY ALLWEIS | RUSSIA, 1943, JDC-ESHEL, ISRAEL

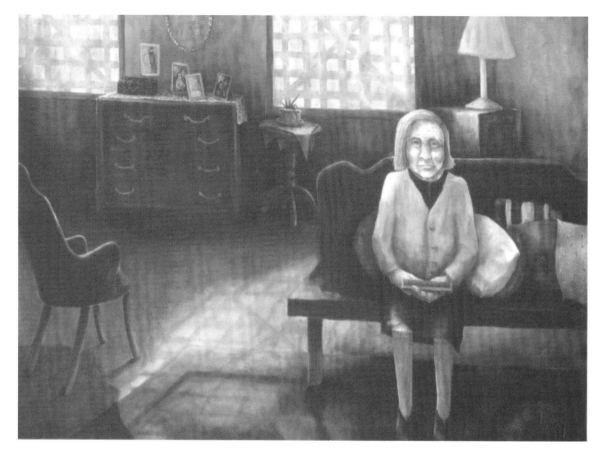

Where Are my Dreams
1992, oil on canvas,
46 x 35 in.

RORY ALLWEIS | JDC-ESHEL, ISRAEL, RUSSIA, 1943,
Education: Self-taught
Selected Exhibitions: Numerous group exhibitions
in Finland, Holland, Brazil, Turkey, Paris, and other
locations.

Curator's statement: The paintings by Rory Allweis
are based on the cycle of life and death in nature, in
the blooming and withering of flowers, the dawn
and close of the day, and seasons of the year. This
cycle symbolizes the cycle of life and death.

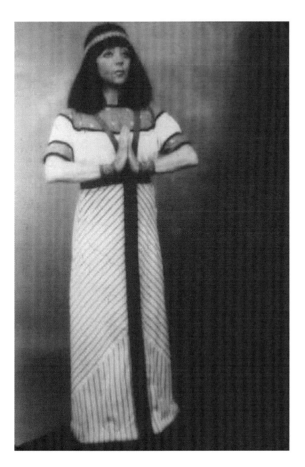

Recollection of My Life with Diaghilev, 1919-1929 by Eleanora Antinova, 1981, tinted silver gelatin print set, 14 x 11 in. each. Courtesy of Ronald Feldman Fine Arts, New York

ELEANOR ANTIN | NEW YORK, NY, 1935

Education: City College of New York

Selected Permanent Collections: Jewish Museum, New York; Los Angeles County Museum; Museum of Modern Art, New York; Whitney Museum of American Art, New York; San Francisco Museum of Art; San Diego Museum of Art; School of the Art Institute of Chicago

Selected Exhibitions: Marella Arte Contemporanea, Milan; Los Angeles County Museum of Art; Whitney Museum of American Art, New York; Ronald Feldman Fine Arts, New York; Los Angeles Institute of Contemporary Art; Museum of Modern Art, New York; Jewish Museum, New York

The calendar tells me I'm growing older but what do I have to do with calendars? When I look in the mirror I don't look old but then I'm not wearing my glasses. They are for reading, not for looking in mirrors. I can't speak for other people. But for myself, the girl-oops, sorry, woman looking back at me (without glasses) in the mirror in the morning is the same one I always knew. A little more confident, perhaps a little smarter, a little tougher, but pretty much the same Ellie I always knew. As Gertrude Stein said, "We are being old for such a very short time."

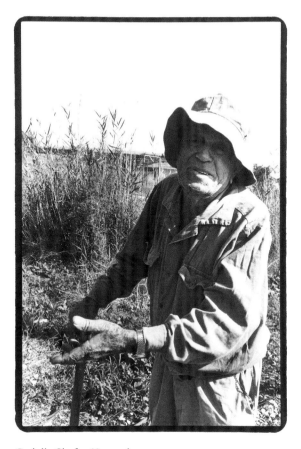

Gedalia Shefer, Yavneel
silver gelatin print,
24 x 20 in. each

ALIZA AUERBACH | JDC-ESHEL, ISRAEL
Education: Philosophy and Bible Studies, Hebrew University, Jerusalem, B.A.
Selected Permanent Collections: Israel Museum; Tel-Aviv Museum; Ein-Harod Museum; Tel-Hai Museum; Museum of Israeli Art, Ramat-Gan; Private collections in USA, Europe, and Israel.
Selected Exhibitions: Ein-Harod Museum, Israel; History Museum, Beijing, China; Israel Museum, Jerusalem; Israeli Embassy, Washington, D.C.; Museum of Israeli Art, Ramat-Gan, Israel

Curator's statement: The photographs of Aliza Auerbach in this exhibit are dedicated to those in the "third age." Auerbach chose to photograph active elderly people who are still engaged in work, whether industry or agriculture, in the field, chicken coop, or cowshed. These old people, with deeply etched wrinkles and veiny hands, are a vital testimony and message to society, which expects old people to move over and make room for the young. The love of work and activity, and acknowledgment of the right and need to work even in old age are the "ideological platform" of one part of society that is not forced to retire.

SAMUEL BAK | VILNA, POLAND, 1933

Education: Bezalel Art School, Jerusalem; Ecole des Beaux-Arts, Paris

Selected Permanent Collections:
Boston Public Library; Holocaust Museum Houston; Israel Museum, Jerusalem; Jewish Museum, New York; Tel Aviv Museum of Art

Selected Exhibitions: Pucker Gallery, Boston; Florida Holocaust Museum, St. Petersburg, FL; Rheinisches Landesmuseum, Bonn; Tel Aviv Museum; Bezalel Museum, Jerusalem; HUC-JIR Museum, New York

Old Man's Departure is an exorcism of the restless spirit of my stepfather, a survivor of Dachau who had lost his wife and two daughters in the Mauthausen camp. There was hardly a night when he did not jump up from the nightmares and awaken us with his screams. When I accompanied him on his last journey, I knew it was his first deep and peaceful sleep in over twenty-five years.

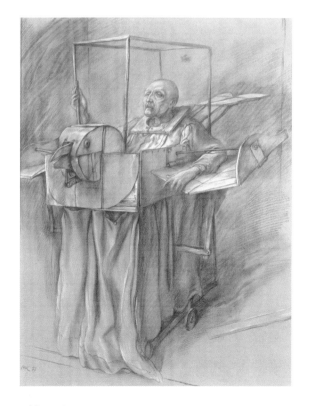

Old Man's Departure, 1977,
charcoal, chalk on paper,
24.5 x 19 in.
Courtesy of Pucker Gallery,
Boston

Flight of Time/Life Passages,
2002, fabric, 12 panels,
54 x 9.5 in. each

MARILYN BANNER | ST. LOUIS, MO, 1945

MARILYN BANNER | ST. LOUIS, MO, 1945
Education: Massachusetts College of Art, Boston,
M.S.Ed.; Washington University, St. Louis, B.F.A.
Selected Permanent Collections: Community for
Creative Nonviolence, Washington, D.C.; National
Museum of Women in the Arts, Washington, D.C.;
Women's International League for Peace and Freedom,
Philadelphia; Massachusetts College of Art, Boston
Selected Exhibitions: Peck Humanities Institute,
Rockville, MD; Georgetown University Lombardi Center,
Washington, D.C.; CERES, New York; District of Columbia
Arts Center, Washington, D.C.; Montpelier Cultural Arts
Center, Laurel, MD

Flight of Time resulted from my looking backward, into
the present, and into the future all at once. The ancestors
place me in a line with my Jewish heritage, and reflect
to me the losses one experiences as one grows older-
losses of the "older generation," as one moves toward
becoming "the older generation."

Mark Berghash | Buffalo, NY, 1935

Education: Art Students League of New York;
University of Buffalo, New York

Selected Permanent Collections: Jewish Museum,
New York; Maison Européenne de la Photographie,
Paris; Metropolitan Museum of Art, New York;
Museum of Modern Art; New York

Selected Exhibitions: Jewish Museum, New York;
Gallery of Photographic Art, Tel Aviv; Marcuse Pfeifer
Gallery, New York; Jerusalem Centre for the
Performing Arts, Jerusalem; National Museum of
American Jewish History, Philadelphia

The title refers to the fact that we are stuck with our
selves and part from our selves after death, maybe.
Doing this project is a reality check. In the mental
realm (spiritual, psychological, emotional, creative)
my life in most respects is richer than ever before.

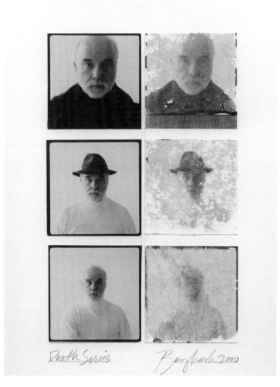

Disintegration,
Polaroid and wet transfer
images, 11 x 14 in.

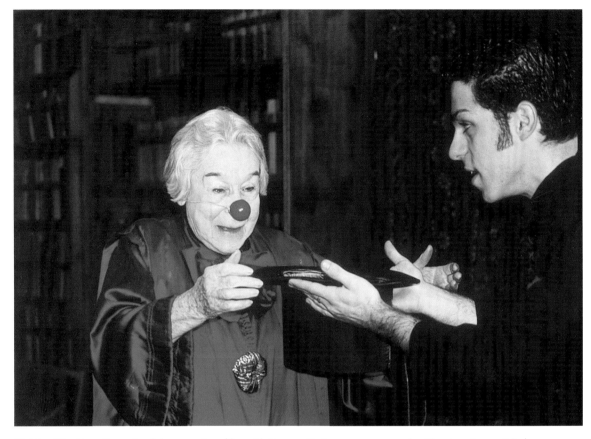

Making Way for a Green Leaf, documentary film with Devora Bertonov, 2000, 12 min. Director: Ayana Friedman

DEVORA BERTONOV | JDC-ESHEL, ISRAEL, RUSSIA, 1915
Education: Bolshoi School, Moscow, then various studies in Germany, England and the U.S.
Selected work: Lecturer on the theory and technique of dance; performed in numerous shows and movies. A movie on her life by Noit and Dan Geva was released in 2000. Recipient of the Israel Prize (1991).

Curator's statement: A day in the life of the actress-dancer Devora Bertonov is documented in this short video. Interspersed with the clips of conversation with her, which present her views on life and aging, are scenes from her most recent show "Upon Turning Out the Lights." In this production, the artist appears as a clown who parts from her role and passes it on to a young actor. "How does the brown leaf know," asks the character, "when to yield its place to the green leaf?"

Tami Bezaleli-Shohet | JDC-Eshel, Israel, 1963

Education: Self-educated

Multimedia artist: Illustration, painting, sculpture, animation

Selected Exhibitions: Jerusalem Artists House. First prize, Fenniger Prize for Young Artists. Ish-Shalom Prize for Art.

Curator's statement: Tami Bezaleli-Shohet does realistic sculptures in rough-carved wood – figures of those aging and elderly. The palms of the hands and feet are deliberately oversized, and the bent-over pose of the bodies is emphasized, as if pulling the figures downward toward the earth. The advanced age of the figures is also conveyed by the natural texture of the wood, showing the tree rings of age.

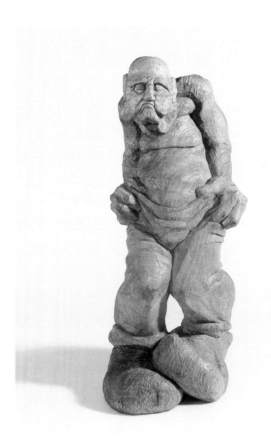

Man, 2000, acomeh wood, 24 x 9 x 11 in.

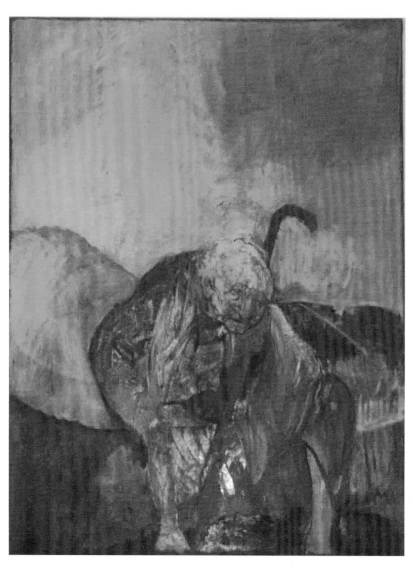

Old Woman in Red,
1957/2003, oil on canvas,
55.5 x 42 in.

HYMAN BLOOM | BRINOVISKI, LATVIA, 1913

HYMAN BLOOM | BRINOVISKI, LATVIA, 1913
Education: Private study with Denman Waldo Ross
and Harold K. Zimmerman Selected Permanent
Collections: Jewish Museum, New York; Metropolitan
Museum of Art, New York; Museum of Fine Arts,
Boston; Art Institute of Chicago

Selected Exhibitions: Museum of Modern Art, New
York; National Academy of Design, New York

The artist's reward is pleasure, ecstasy from contact
with the unknown – Hyman Bloom All art deals with
intimations of ~~immortality~~ mortality – Mark Rothko
(amended by Hyman Bloom)

ANDRÁS BÖRÖCZ | BUDAPEST, HUNGARY, 1956

Education: Hungarian Academy of Fine Arts, Budapest

Selected Exhibitions: Jewish Museum, Budapest; Adam Baumgold Fine Art, New York; Temple Judea Museum, Elkins Park, PA; Janus Pannoius Muzeum, Pecs, Hungary; Armory, New York; Cooper Union, New York; Museum of Fine Arts, Budapest

András Böröcz started to work with pencils more than 10 years ago. The pencil, which is often the tool to create art, is here used as the art material. His earlier works ranged from carved tiny figures from a single pencil to carved life-size plant-like figures consisting of thousands of glued together pencils. The pencil has become, in a sense, his signature material.

The pencil appears here as content and context: a box, made of painted glued together pencils, holds a small pencil tableau. Behind the carved pencil figures there is a drawing of a scene out of a window or a drawing on the wall, or both, each representing a larger pencil universe. The themes of these pencil genre boxes are oftentimes absurd, particularly when these miniatures address archetypal motifs, like 'The Artist in his Studio.'

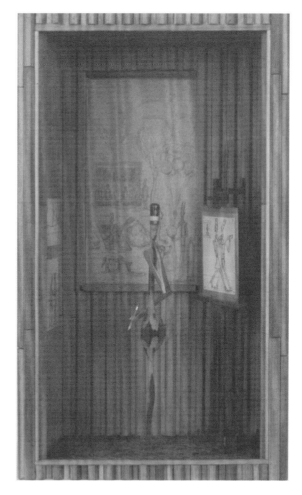

Draftsman: The Funeral, 2001, mixed media, 12.75 x 7.75 x 4.2 in. Courtesy of Adam Baumgold Gallery, New York

YAEL BRAUN | PRAGUE, 1921, JDC-ESHEL, ISRAEL

Grandfather and the Birds, 1978,
oil pastel on brown paper,
20 x 13 in.

YAEL BRAUN | JDC-ESHEL, ISRAEL, PRAGUE, 1921
Education: Self-taught.
Selected Exhibitions: Participated in various group shows

Curator's statement: Family members, especially the grandfather who appears frequently in the drawing of Yael Braun, testify to the warm memories of the artist. These were very special memories for her, providing emotional sustenance and support throughout her life. These figures always appear smiling, optimistic, and happy.

For Braun, these paintings are a way to connect with the wealth of memories from her ties over the years with the older generations of her family, including her grandfather who perished in the Holocaust. This rich storehouse of memories forms part of her to this day.

ROBERT BRONER | DETROIT, MI, 1922

Education: Wayne State University, Detroit, M.A., B.F.A.

Selected Permanent Collections: Bibliothèque
Nationale, Paris; Boston Public Library; Brooklyn
Museum of Art, New York; Fogg Museum, Harvard
University, Cambridge, MA; Guggenheim Museum,
New York; Israel Museum, Jerusalem; Metropolitan
Museum of Art, New York; Museum of Modern Art,
New York

Selected Exhibitions: HUC-JIR Museum, New York;
Israel Museum, Jerusalem; Merging One Gallery, Santa
Monica, CA; J.L. Hudson Gallery, Detroit; Delson Richter
Gallery, Tel Aviv

Literally and metaphorically we are presented with
bodies falling through unbounded space. Such a
metaphor is usually associated with the coming into
consciousness in most creation myths, the primal
couple moving from the Edenic womb of gratified
needs into the shock of individuation which involves
the apprehension of their own mortality. Finally, they
evolve into an acceptance of their situation that allows
them to be playful. The bodies now display a grace, a
sensuousness in relation to each other that can only
be achieved by combining the fact of their external
condition with spiritual/ psychological insight. In this
attitude, their nakedness no longer reads as
helplessness but as ecstasy.

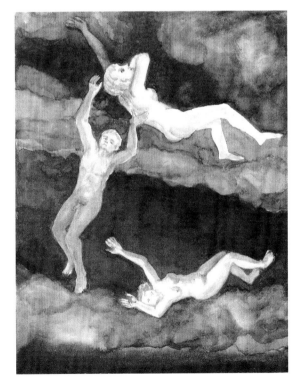

Unbounded Space, 2002,
water color on paper,
4 paintings, 15 x 12 in. each

MARILYN COHEN | NEW YORK, NY, 1938
Education: School of Visual Arts, New York
Selected Permanent Collections: University of Utah,
Salt Lake City; Gladstone Collection of Baseball Art,
Lehigh University, Bethlehem, PA
Selected Exhibitions: HUC-JIR Museum, New York;
Yeshiva University Museum, New York; Art in
Embassies Program, U.S. Department of State, U.S.
Ambassador Residence, Montevideo, Uruguay

Age has never been of importance to me. Aging,
however, seems to be another matter. Could it be
that some subconscious introspection is causing
my work, now, to deal not only with family, but also
with the passage of time?

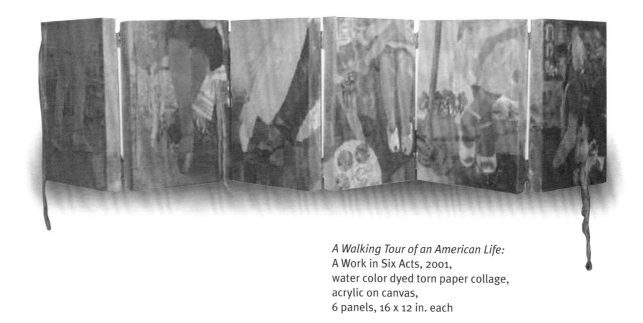

A Walking Tour of an American Life:
A Work in Six Acts, 2001,
water color dyed torn paper collage,
acrylic on canvas,
6 panels, 16 x 12 in. each

Robi Cohen | Bucharest, Romania, 1950
Education: University of Florence, Italy, M.A., B.A.
Selected Exhibitions: Holon Art Gallery, Tel Aviv;
Argaman Art Gallery, Tel Aviv; Palazzo Strozzi,
Florence; Tel Aviv City Hall

My works depict a journey through interiors and
exteriors blurring the lines of realism and
psychological intimacy. *Growing Distance* continues
this existential exploration. The painting's structure
suggests a layering of one's life – whether
chronology or point of view.

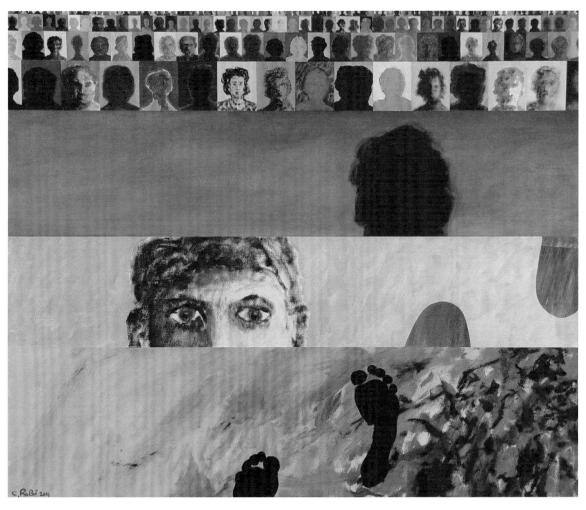

Growing Distance, 2000,
oil on canvas,
28 x 34 in.

JULIE DERMANSKY | NEW YORK, NY, 1966

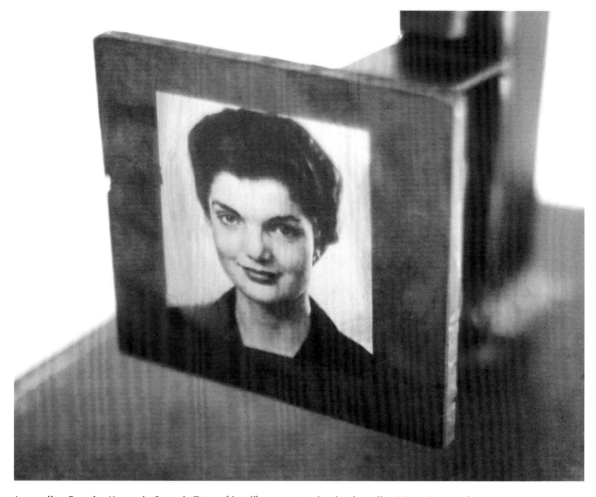

Jacqueline Bouvier Kennedy Onassis Totem (detail), 2003, steel, mixed media, 86.5 x 8 x 12.5 in.

JULIE DERMANSKY | NEW YORK, NY, 1966
Education: Arizona State University, Tempe, M.F.A.;
Sophie Newcomb College, Tulane University, New
Orleans, B.F.A.
Selected Permanent Collections: Milwaukee Art
Museum, WI
Selected Exhibitions: HUC-JIR Museum, New York;
The Art Mission, Binghamton, NY; Boudior, Berlin;
Andy Jllien Gallery, Zurich; University of Connecticut;
Bronfman Gallery, JCC of Washington, D.C.

Youth is overrated. Age brings wisdom and answers.
Many seem to fight the aging process, others go with
it and their inner beauty and strength grow with them.

David Deutsch | New York, NY, 1929
Education: Pratt Institute, New York, B.A.
Selected Permanent Collections: New Britain Museum of American Art, CT
Selected Exhibitions: Carlynn Gallery, Delray, FL; Ora Sorenson Gallery, Delray, FL; Noho Gallery, New York; Galleries International Inc., East Hampton, NY and Palm Beach, FL

My father told me "The first thing that goes are your knees." He was right. I stop reading before I want to because my eyes get tired. If I paint more than five hours, my back aches. The volume button on our TV is up several decimals lately. It's insidious. Your parts wear out. I'm so grateful that none of them are broken.

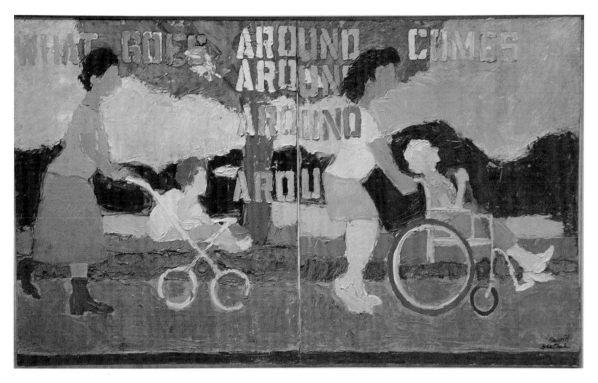

What Goes Around Comes Around, 1999,
oil on canvas,
45 x 60 in.

MARY REGENSBURG FEIST | NEW YORK, NY, 1914

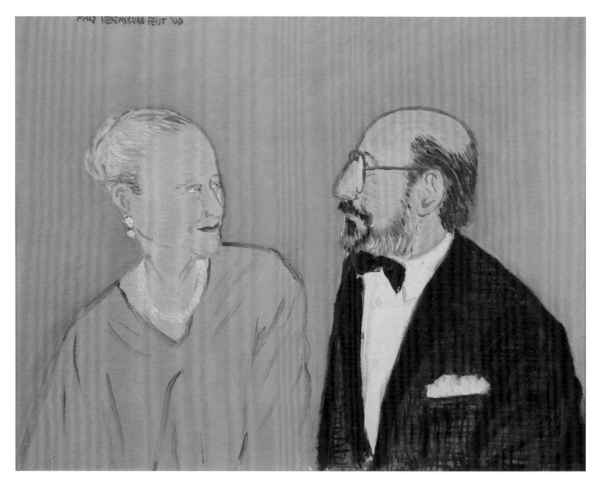

Mary and Leonard, 2000, oil on canvas, 24 x 30 in.

MARY REGENSBURG FEIST | NEW YORK, NY, 1914
Education: Grand Central Art School, New York;
Private study with John Sloan, New York
and Santa Fe
Selected Permanent Collections: New Mexico
Museum of Fine Arts, Santa Fe
Selected Exhibitions: Montross Gallery, New York;
Saidenberg Gallery, New York; Santa Fe Museum of

Art; Westmoreland Museum of Art, Greensburg, PA;
Wigmore Gallery, New York

This double portrait of my late husband and me was
inspired by a snapshot taken of us when we were
on a cruise. It speaks to me about our marriage and
our feelings for each other. Our marriage lasted 60
years.

MAX FERGUSON | NEW YORK, NY, 1959

Education: New York University B.S.; Gerrit Rietveld Academie, Amsterdam

Selected Permanent Collections: Metropolitan Museum of Art, New York; New York Public Library; New York Historical Society; Museum of the City of New York; Forbes Magazine Collection

Selected Exhibitions: ACA Galleries, New York; Art for Embassies Program, U.S. State Department, New York; Ogunquit Museum of American Art, ME; Armory, New York; Museum of the City of New York

I spent the first 30 years of my life as perhaps the world's most self-hating Jew. Since then I have returned more and more to my *Yiddishkeit*, and have become increasingly observant. My work has always been essentially autobiographical and this work is a reflection of that.

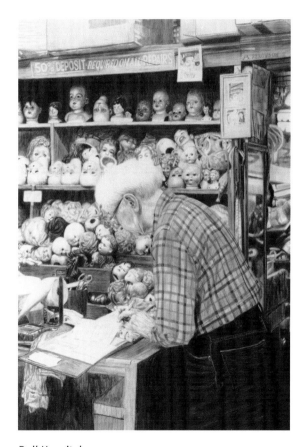

Doll Hospital, 2003,
graphite on paper,
18 x 12 in.
Courtesy of ACA Gallery,
New York

34

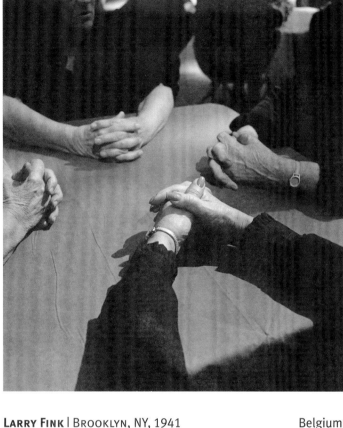

Clasped Hands,
March, 1987
silver gelatin print,
20 x 16 in. each

LARRY FINK | BROOKLYN, NY, 1941

LARRY FINK | BROOKLYN, NY, 1941
Education: Private study with Lisette Model
Selected Permanent Collections: Whitney Museum
of American Art, New York; Metropolitan Museum
of Art, New York; Museum of Modern Art, New York;
Bibliothèque Nationale, Paris; Library of Congress,
Washington, D.C.; Museum of Fine Art, Boston;
Smithsonian Museum, Washington, D.C.
Selected Exhibitions: Whitney Museum of American
Art, New York; Musée de la Photographie, Charleroi,

Belgium; Musée de l'Elysee, Lausanne, Switzerland;
Museum of Modern Art, New York; Jewish Museum,
New York

I spent some months in the late '80s within the
community of activist women in Minneapolis,
Minnesota. These images express fortitude,
patience, and time. I thank that experience for
deepening my perceptions of women and thus giving
me more dimensionality as a man.

Audrey Flack | New York, NY, 1931

Education: Cooper Union, New York; Yale University, New Haven, CT, B.F.A.

Selected Permanent Collections: National Museum of American Art, Smithsonian Institute, Washington, D.C.; National Museum of Women in the Arts, Washington, D.C.; Stuart M. Speiser Collection, Smithsonian Institute, Washington, D.C.; Metropolitan Museum of Art, New York; Museum of Modern Art, New York; Guggenheim Museum, New York; Whitney Museum of American Art, New York

Selected Exhibitions: HUC-JIR Museum, New York; Cooper Union, New York; National Museum of Women in the Arts, Washington, D.C.; Guild Hall Museum, East Hampton, NY

I didn't know how much longer she would live. I had to capture her life, her face, her expression. I asked her to pose for me. She didn't want to. She was impatient. "Just for an hour," I pleaded. I worked feverishly and caught my mother.

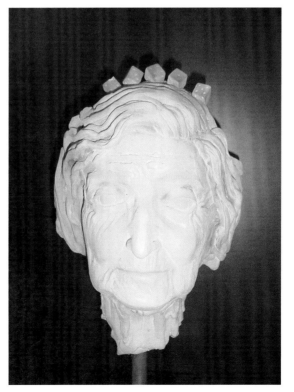

Portrait of Mother, 2003,
composite plaster
12 x 8 x 8 in.

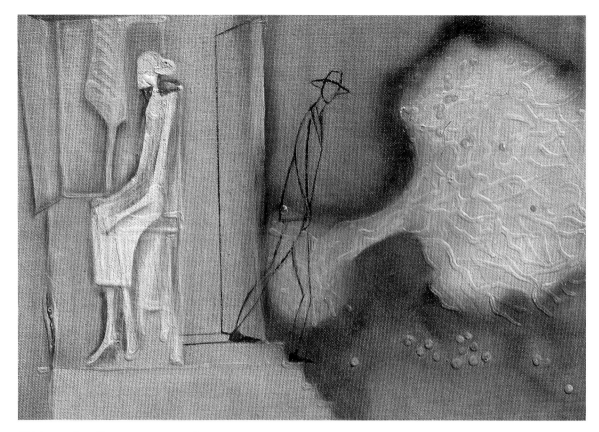

Old Age, 1989, oil on canvas, 12 x 14 in.

PAUL FUX | JDC-ESHEL, ISRAEL, ROMANIA, 1922
Education: Academy of Arts, Budapest
Selected Exhibitions: Selected exhibitions in Jerusalem, Beersheba, and Tel Aviv;
Member of the Association of Miniatures

Curator's statement: The work of Paul Fux frequently reflects transitions from one period to another, from one essence to another. These include the transition from maturity to old age and from this to other worlds. The tree as a symbol of truncated life appears in another drawing of Fux from 1989, in which a man can be seen turning his back on a woman. She appears as a silhouette, a kind of memory, and he exits through the door toward a felled tree.

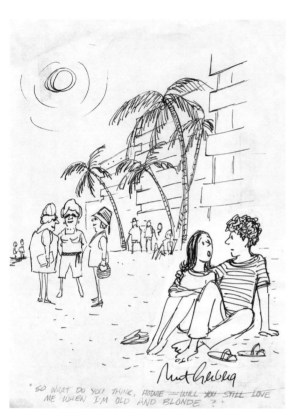

So What Do You Think, Howie,
11 x 8 in.

Mort Gerberg | Brooklyn, NY

Education: City College of New York, B.A.

Selected Publications: *Look; The Saturday Evening Post; Harper's; The Saturday Review; Publisher's Weekly; Playboy; The New Yorker; Harvard Business Review*

Selected Books: *Cartooning: The Art and the Business; Joy in Mudville; The Big Book of Baseball Humor; Bearly Bearable; Geographunny; The All-Jewish Cartoon Collection; More Spaghetti, I Say Art, you should take it personally.*

Paintings, sculpture, drawings, whatever, are all highly subjective responses by their creators to Life As We Know It – or *think* we know it. We cartoonists, though, usually go a step further. Our emotional responses are stronger (outrage is the best) so we twist exaggerated opinions into our art that make it funny - and hope that others find it funny, too. My cartoons, like most others, are informed by a lifetime of favorite likes, dislikes, prejudices, beliefs, disbeliefs and heavy skepticism and are about anything and everything. No subjects are off-limits, especially those I know little about or are uncomfortable with. My not-so-secret-identity as a cartoonist, I feel, gives me full license – yes, even an obligation – to *kvetch* about it all.

Like the subject of aging. I mean, who wants to get old? Who needs this? It's a pain! So to deal with it, I create cartoons about it. And though the cartoons don't solve the problem of aging, they may make them a little easier to live with.

Education: New York University, M.A.; Antioch College, Yellow Springs, OH, B.A.

Selected Permanent Collections: Europos Parkas, Vilnius, Lithuania; Islip Museum, East Islip, NY; Borough of Manhattan Community College, New York; Executive Temps, Raleigh, NC; Waterworks Gallery, Friday Harbor, WA

Selected Exhibitions: Bronx Museum of the Arts, New York; HUC-JIR Museum, New York; Art/Umjetnost, Obala Theatre, Sarajevo; Cooper-Hewitt Museum, New York; United Nations Women's Conference, Nairobi; Bronfman Gallery, JCC of Washington, D.C.; University of Connecticut.

I create works which bring together art and poetry by cutting images and texts into formed steel sculptures using a welding torch as a drawing instrument. I combine the tactile, spatial forms of sculpture with elegant, succinct comments on contemporary social issues.

Honor, Celebrate..., 1993, welded steel, 33 x 19 x 22 in.

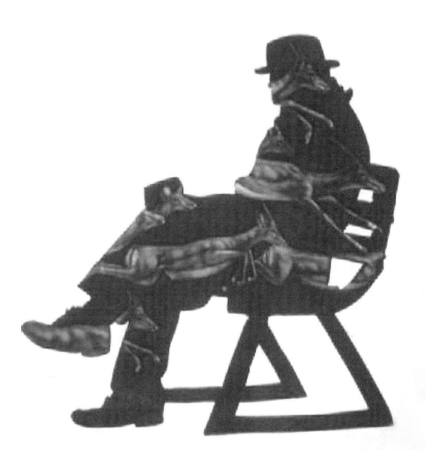

Evening, 1990,
porcelain enamel on metal,
24 x 24 in.

GRACE GRAUPE-PILLARD | NEW YORK, NY, 1945

Education: Art Student's League of New York; City College of New York, B.A.

Selected Permanent Collections: Library of Congress, Washington, D.C.; Johnson & Johnson, New Brunswick, NJ; Coca-Cola Corporation, Atlanta; Malcolm Forbes, Forbes Publications, New York; Bell Atlantic Headquarters, Washington, D.C.; Prudential Insurance Company, Newark, NJ

Selected Exhibitions: Museum of Modern Art, New York; Museum of Modern Art, Venice; Frist Center for Visual Arts (Gordon CAP Gallery), Nashville; Donahue/Sosinski, New York; New Jersey State Museum, Trenton

Inside the darkened silhouette the work presents the essence of youth and speed, as a group of impalas leap with the joy of life, conveying the liveliness of the interior self which cannot and will not be suppressed by the outwardly physical exterior of aging.

39

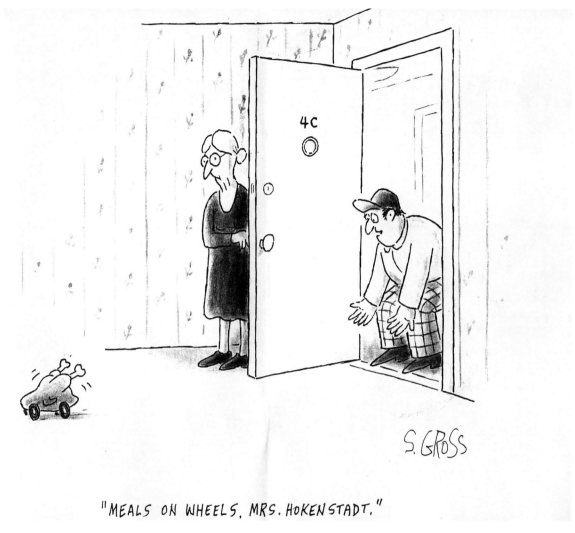

"MEALS ON WHEELS, MRS. HOKENSTADT."

It's Meals on Wheels, Mrs. Hokenstadt, 1992, 14 x 11 in.

SAMUEL H. GROSS | NEW YORK CITY, 1933
Education: City College of New York, B.B.A
Sam Gross began cartooning in 1962. His cartoons have appeared in such magazines as *The New Yorker, Harvard Business Review, Esquire, Cosmopolitan,* and *Good Housekeeping*. Gross was the Cartoon Editor of *National Lampoon* and *Parents Magazine*. His cartoon collections include *More Gross, An Elephant is Soft and Mushy, Your Mother is a Remarkable Woman, I am Blind and My Dog is Dead,* and *Catss by Gross*. In the late 1990s, he became involved in electronic publishing ventures with cartoons playing an important role.

Maty Grünberg | England

Education: Bezalel Academy of Art, Jerusalem;
Central School of Art, London

Selected Permanent Collections: Victoria and Albert
Museum, London; British Museum, London; Jewish
Museum, New York; New York Public Library; HUC-
JIR Museum, New York; HUC-JIR, Jerusalem

This piece consists of two elements, which visually
portray the map of Israel from 1947 until today. The
map is drawn from memory and so is not a
cartographer's map. The various lines in different
colors represent the borders as they have evolved,
much like the lines we develop with age on our
brows.

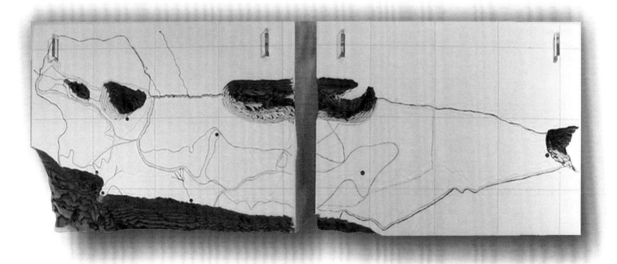

*Aging: The State of
Israel,* 2003,
ink on paper, 20 x 61 in.

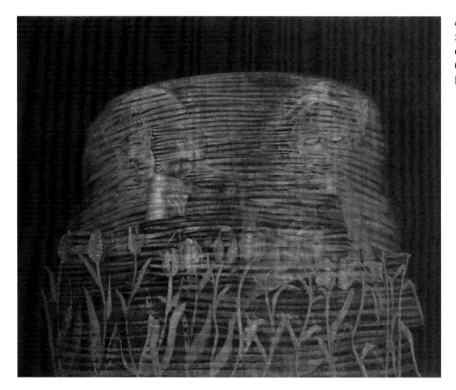

Me & Me & Tulips in Time,
2003,
oil on canvas, 48 x 58 in.
Courtesy of Julian Weissman
Fine Arts, New York

KAREN GUNDERSON | RACINE, WI, 1943

KAREN GUNDERSON | RACINE, WI, 1943
Education: The University of Iowa, Iowa City, M.F.A.
in Intermedia; Wisconsin State University,
Whitewater, B.S.Ed.
Selected Permanent Collections: Dow Jones, New
York; Metropolitan Life Insurance Company, New
York; General Electric Company, Bridgeport, CT;
Philip Morris Incorporated, New York; Bellevue
Hospital Center – Bellevue's Mental Health Art
Project, New York
Selected Exhibitions: Government Ministry, Sofia,
Bulgaria; Holocaust Museum Houston, Museum of
Fine Arts, Racine, WI; Pratt Institute, New York; ACA
Gallery, Munich; HUC-JIR Museum, New York

The tulip is my metaphor for aging. It begins
columnar, closed, firm. As it ages, it opens and
softens. As it ages more, it becomes more open,
wrinkled and fragile. Each state has its own beauty
and its own wisdom. The portrait on the left is of
me at 30, the one on the right at 59. We (the two of
me) are observing and hopefully mirroring the tulip's
transitions.

Carol Hamoy | New York, NY, 1934

Education: Art Students League of New York; Newark School of Fine and Industrial Arts, NJ

Selected Permanent Collections: National Museum of Women in the Arts, Washington, D.C.; Washington Jewish Historical Society, Washington, D.C.; Lower East Side Tenement Museum, New York; HUC-JIR Museum, New York

Selected Exhibitions: Skirball Museum, Cincinnati; Ellis Island Immigration Museum, New York; National Museum of American Jewish History, Philadelphia; Lower Manhattan Cultural Council, New York; HUC-JIR Museum, New York; University of Connecticut; Bronfman Gallery, JCC of Washington, D.C.

When a person is an artist, "retirement" is not a consideration – it doesn't exist. Creativity doesn't just stop because you've reached a certain age. Being creative, being an artist, is yours to be for all of your life. It pleases me to be aging as an art(ist) – it's a life of purpose and value.

Six Months (detail), 2002,
mixed media,
10.5 x 47.5 x 0.75 in.

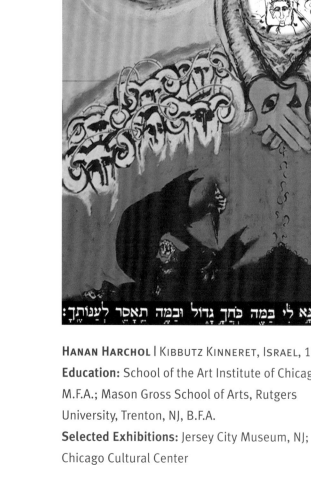

כִּי־יַעַן עָשִׂיתָ אֶת־הַדָּבָר הַזֶּה וְלֹא חָשַׂכְתָּ אֶת־בִּנְךָ אֶת־יְחִידֶךָ: כִּי־בָרֵךְ אֲבָרֶכְךָ וְהַרְבָּה אַרְבֶּה אֶת־זַרְעֲךָ כְּכוֹכְבֵי הַשָּׁמַיִם וְכַחוֹל אֲשֶׁר עַל־שְׂפַת הַיָּם

וַתֹּאמֶר דְּלִילָה אֶל־שִׁמְשׁוֹן הַגִּידָה־נָּא לִי בַּמֶּה כֹּחֲךָ גָדוֹל וּבַמֶּה תֵּאָסֵר לְעַנּוֹתֶךָ:

Witnessing Sacrifice,
2003, multi-media,
116 x 96 x 26 in.

HANAN HARCHOL | KIBBUTZ KINNERET, ISRAEL, 1970
Education: School of the Art Institute of Chicago,
M.F.A.; Mason Gross School of Arts, Rutgers
University, Trenton, NJ, B.F.A.
Selected Exhibitions: Jersey City Museum, NJ;
Chicago Cultural Center

I explore psychological and sociological themes of
empowerment and disempowerment through
juxtaposed narratives. These narratives include
autobiographical, biblical, and mythological themes
as well as those from popular culture and humor.

HANAN HARCHOL | KIBBUTZ KINNERET, ISRAEL, 1970

Judah S. Harris | Rochester, N.Y., 1965
Selected Peranent Collections: Museum of Jewish Heritage, New York
Selected Exhibitions: Jewish Museum, New York; Beth Hatefutsoth, Tel Aviv

I tell people that I photograph Jewish life and life in general. A lot of my pictures are inherently Jewish— Israel, Jewish people, culture, ritual; but life is also a Jewish concept. Judaism stresses discovering life, making the most of it. I think we're all supposed to find out what it's all about. I explore all of this through photography and part of that is sharing my exploration with others.

Azalea, 1987,
photography,
13 x 9 in.

But When You Live,
ink on paper,
14 x 10.5 in.

"UT WHEN YOU LIVE 900 YEARS, YOU FIND
AT YOUR GREAT-GREAT-GREAT-GREAT-GREAT
REAT-GREAT-GREAT GRANDCHILDREN NEVER
OME TO VISIT."

SIDNEY HARRIS | BROOKLYN, NY, CIRCA 1930
Selected Publications: *Playboy; The Wall Street Journal; Science; The New Yorker; Punch; The Spectator*
Selected Books: *Stress Test: Cartoons on Medicine;* *So Sue Me!: Cartoons on Law; 49 Dogs, 36 Cats, & a Platypus: Animal Cartoons; Einstein Simplified: Cartoons on Science; Freudian Slips: Cartoons on Psychology; There Goes the Neighborhood: Cartoons of the Environment; Winners and Losers*

ELLEN HARVEY | KENT, ENGLAND, 1967

Education: Yale Law School, New Haven, CT, J.D.; Harvard College, Cambridge, M.A., B.A.

Selected Permanent Collection: Whitney Museum of American Art, New York

Selected Exhibitions: Mizuma Gallery, Tokyo; Saint Peter's Church, New York; The International Monetary Fund, Washington, D.C.; Neue Galerie am Landesmuseum Joanneum, Graz, Austria; New Museum of Contemporary Art, New York; Whitney Museum of American Art/Altria, New York

ID Card Project is a self-portrait that tries not to be about self-expression. Inevitably, as such, it fails. It consists of 25 small paintings of each identity card that I still own arranged in chronological order. The first was taken at age fourteen, the last at age twenty-nine. To paint from identity cards is to reference the originally indexical nature of photography. Each card points to a moment and it's wholly functional in intent. A painting as documentation of an event is perverse.

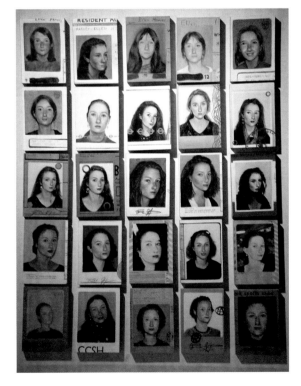

ID Card Project, 1998.
oil on Masonite,
25 panels, 7 x 5 in. each
Collection of Linda and John Farris

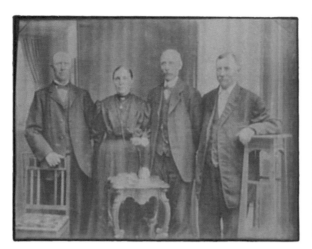

Just Passing Thru, 1997, photo/graphite drawing, diptych, 7 x 9 in. each

FRANCES HEINRICH | PASSAIC, NJ, 1943
Education: Columbia University, New York, M.A.;
Douglass College, Rutgers University, Trenton, NJ,
B.A.
Selected Exhibitions: Gallery at Bristol-Myers
Squibb, Lawrence Township, NJ; Borowsky Gallery,
Philadelphia; Noyes Museum of Art, Oceanville, NJ;
Newark Museum, NJ

My work is concerned with frailty and vulnerability,
aging and regeneration. It investigates deep
connections between human and natural worlds and
explores the unfathomed dimensions of mind, body,
and soul.

Albert Hirschfeld | St. Louis, MO, 1903-2002
Education: Art Students League of New York
Selected Permanent Collections: Metropolitan Museum of Art, New York; Museum of Modern Art, New York; Whitney Museum of American Art, New York; St. Louis Art Museum; Margo Feiden Galleries, New York

Selected Exhibitions: Harry Ransom Humanities Research Center, University of Texas, Austin; San Francisco Performing Arts Library & Museum; American Vision 145 Gallery, New York; Museum of the City of New York

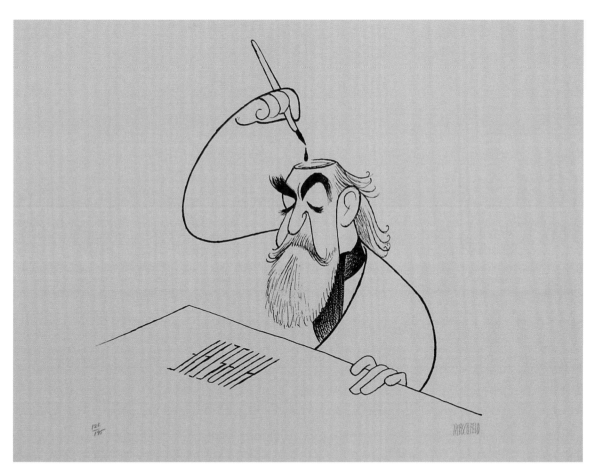

Self Portrait as Inkwell,
The Artist at 95, 1997,
126/195, 17 x 19 in.
Courtesy of Margo Feiden Gallery,
New York

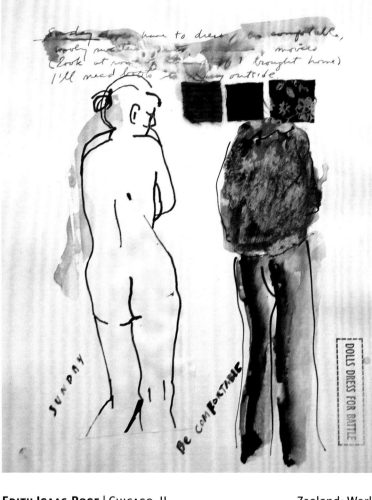

Dolls Dress for Battle, 2003, mixed media, water color, ink, 13.75 x 11 in. each

EDITH ISAAC-ROSE | CHICAGO, IL

EDITH ISAAC-ROSE | CHICAGO, IL
Selected Permanent Collections: Equitable Life Assurance Society, New York; Manhattan Community College, New York; Marriott Marquis, Atlanta; Northwestern University, Evanston, IL; HUC-JIR Museum, New York
Selected Exhibitions: HUC-JIR Museum, New York; Art Works, New York; Open Studio, Assisi, Italy; A.I.R., New York; Akaroa Art Center, Akaroa, New Zealand; World Trade Center, New York; Cooper Union, New York; New School, New York

As women age their choices of fashionable apparel become limited by the perceived notion that their life experiences are few. I created this fictional brand label of Dolls Dress for Battle and designs for clothing that are as interesting, complex and comfortable as the "dolls" who are out there.

JANE JOSEPH | ENGLAND, 1942

Education: Camberwell School of Art, London

Selected Permanent Collections: Arts Council of Wales; Castle Museum, Norwich, England; British Museum, London; Fitzwilliam Museum, Cambridge, UK

Selected Exhibitions: HUC-JIR Museum, New York; Morley Gallery, London; Scarborough Art Gallery, Yorkshire; Edinburgh Printmakers, Scotland; Flowers East, London

My work changed during the middle of the 1970s and I became more directly involved with the visible world. Drawing is fundamental to me. Four Studies of a Hyacinth are drawings from observation of a hyacinth flower, the far left and far right show the flower respectively in youth and in old age and the center two in middle age.

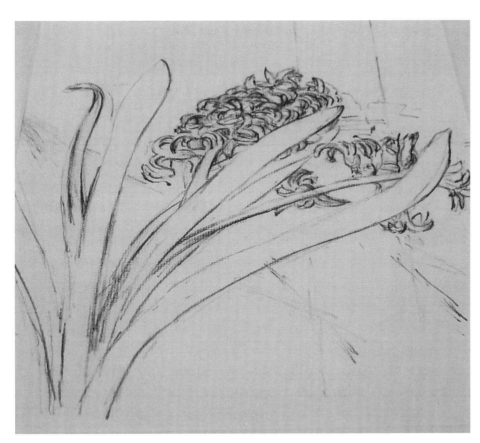

Hyacinth (detail), four studies, 2003, pencil drawing, 16.5 x 48 in.

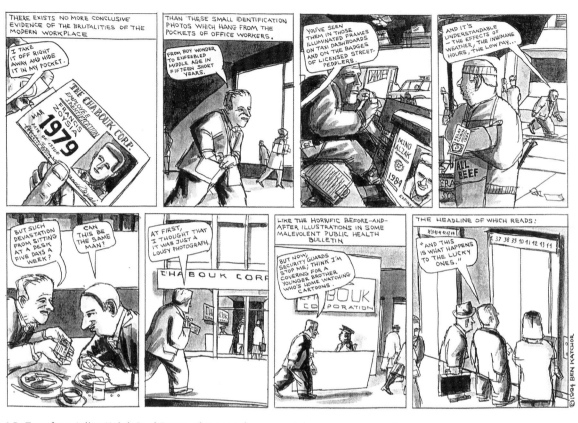

I.D. Tags from Julius Knipl, Real Estate Photographer, 1994, ink on paper, 11 x 17 in.

BEN KATCHOR | BROOKLYN, NY, 1951

Education: Brooklyn College, New York, B.A.

Selected Exhibitions: HUC-JIR Museum, New York; Jewish Museum, New York; Jewish Museum of San Francisco

Selected Publications: *Metropolis Magazine; Forward*

Selected Books: *Cheap Novelties, The Pleasures of Urban Decay; Julius Knipl, Real Estate Photographer: Stories; The Jew of New York; The Beauty Supply District; Le Juif de New York*

Yuri Kuper | Moscow, 1940

Education: Moscow Art Academy

Selected Permanent Collections: Pushkin Museum, Moscow; Museum of Modern Art, New York; Fonds National d'Art, Contemporain, Paris; Metropolitan Museum of Art, New York; Library of Congress, Washington, D.C.; Ministry of Culture, Paris; National Gallery, Oslo

Selected Exhibitions: Galerie Rambert, Paris; Yoshii Gallery, Tokyo and New York; Bouqinerie de l'Institut, Paris; Sainsbury Center for Visual Arts, Norwich, UK; Musée de Toulon, France; FIAC, Los Angeles; Pushkin Museum, Moscow; Galerie Patrick Cramer, Geneva

Fascinated by surfaces, the artist paints everyday objects from his studio, often incorporating features of the existing surface into the finished work. He plays with notions of illusion and reality.

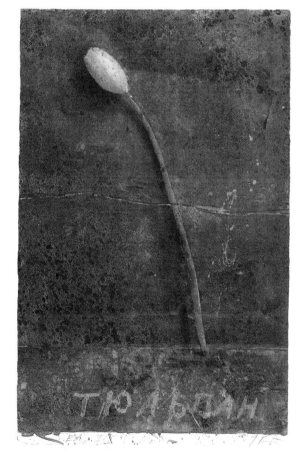

Tulpan (Tulip), 2000, lithograph, 41.25 x 26.25 in. Courtesy of Pettibone Fine Art, New York

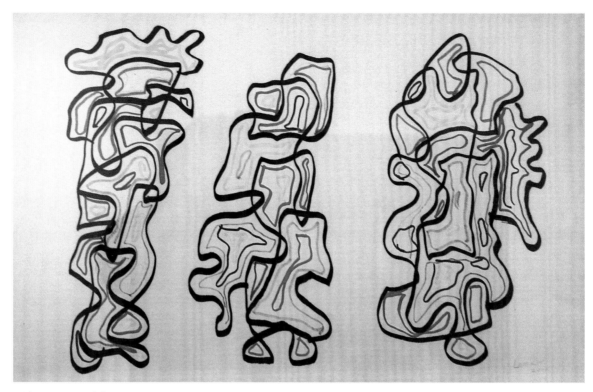

3 Shapes, 2001, ink on paper, 16.5 x 26 in.

IBRAM LASSAW | EGYPT, 1913

Selected Permanent Collections: Guggenheim Museum, New York; Israel Museum, Jerusalem; Metropolitan Museum of Art, New York; Museum of Modern Art, New York; Whitney Museum of American Art, New York; National Museum of American Art, Washington, D.C.

Selected Exhibitions: Whitney Museum of American Art, New York; National Museum of American Art, Washington, D.C.; Accademia d'Arte Dino Scalabrini, Montecatini Terme, Italy

The work is a representation like music. A big trend in all modern art is away from representation.

IBRAM LASSAW | EGYPT, 1913

JOANNE LEONARD | LOS ANGELES, CA, 1940

Education: San Francisco State University, graduate study in photography; University of California, Berkeley, B.A.

Selected Permanent Collections: San Francisco Museum of Modern Art; International Museum of Photography, George Eastman House, Rochester, NY; American Arts Documentation Centre, University of Exeter, England; U.S. State Department, Art in Embassies Collection

Selected Exhibitions: San Francisco Museum of Modern Art; Statue of Liberty National Monument, Port of New York; Whitney Museum of American Art, New York; John F. Kennedy Center for the Performing Arts, Washington, D.C.

Using words and images, including a series of portraits of her grandmother by photographer Edward Weston, Leonard traces relationships and resemblances among women in her family while exploring the process of remembering and the tragedy of memory loss. Lucy Lippard has said that the work connects personal and political histories, the Holocaust, genetics, feminism, and photography.

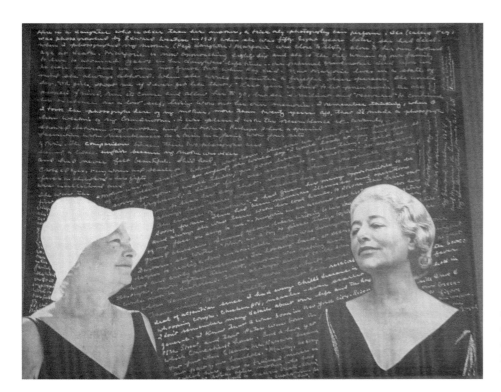

Conversation: My Mother and Her Mother, 1992, gelatin silver print, 16 x 20 in.

Kaddish, 1995,
ink, wash on linen,
39 x 29.75 in.
From the collection
of Dr. Norman J. Cohen

JANE LOGEMANN | MILWAUKEE, WI, 1942

JANE LOGEMANN | MILWAUKEE, WI, 1942
Education: University of Wisconsin, B.A.
Selected Permanent Collections: Museum of
Modern Art, New York; Guggenheim Museum, New
York; Whitney Museum of American Art, New York;
Jewish Museum, New York; British Museum, London;
Bibliothèque Nationale, Paris
Selected Exhibitions: HUC-JIR Museum, New York;
Work Space, New York; Yeshiva University Museum,
New York; AIR Gallery, New York; Los Angeles
Institute of Contemporary Art; Jewish Museum, New
York; Philadelphia Art Alliance

At the time I was dealing with the idea of *Kaddish,*
I was in the center of a personal tragedy in our
family. I was dealing with that fact along with
digesting the possibility of using the *Kaddish* as a
memorial for this relative, or a personal way of
honoring a death and extending that as an artist in
an objective way. The work moves from light to dark
with the association of death but confirms within it
a reaffirming of life.

Susan Malloy | New York, NY, 1924

Education: Skidmore College, Saratoga Springs, NY, B.S.

Selected Permanent Collections: Burndy Library, Norwalk, CT; Juniata College, Huntingdon, PA; Fred F. French Realty Company, New York; Skidmore College, Saratoga Springs, NY; Westport School Arts Collection, Westport, CT; HUC-JIR Museum, New York

Selected Exhibitions: ACA Gallery, New York; Art-USA, Madison Square Garden, New York; Panoras Gallery, New York; Harvard University Divinity School, Cambridge, MA; Allied Artist of America, New York; HUC-JIR Museum, New York

My main viewpoint as a painter has been to use pattern, shapes, spaces, lines, and color in landscapes or skyscapes. For many years I have used trees and clouds as themes and as metaphors for the abstract parts of the composition. At times I have used non-figurative elements as design of a particular project, but have returned to nature again.

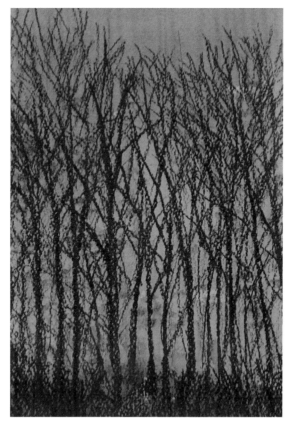

Trees at Sunset, 2000,
pencil on paper drawing,
26 X 20 in.

In Focus
24 x 24 in.

MARGALIT MANNOR | TEL AVIV, ISRAEL
Education: Avni Institute of Fine Arts, Tel Aviv; Hebrew University, Jerusalem, B.A.
Selected Permanent Collections: Haifa Museum of Modern Art; Tel Aviv Museum; Museum of Modern Art, New York; Israel Museum, Jerusalem; Jewish Museum, New York; British Museum, London
Selected Exhibitions: Haifa Museum of Modern Art; Jewish Museum, New York; Tel Aviv Museum; Israel Museum, Jerusalem

"A fugue is a musical form in which several voices play with and against each other. The main theme of fugue is usually introduced by one voice at a time, each voice repeating the main theme while the other voices play secondary themes in the background. Various transformations occur to this main theme in the course of fugue. Sections, which contain the theme, are usually separated by brief and lighter interludes." Program notes from Daniel Barenboim Bach recital, Tel Aviv, August 2003

Yehudit Matzkel | JDC-Eshel, Israel,
Rumania, 1952
Selected Exhibitions: Janko-Dada Museum, Ein
Harod, Israel; Land of Israel Museum, Tel-Aviv;
Municipal Gallery, Rehovot, Israel; The Art Place,
Rishon Lezion, Israel; Museum of Israeli Art, Ramat-
Gan, Israel; The Tower Gallery, Land of Israel
Museum, Tel Aviv

Curator's statement: In Yehudit Matzkel's
photograph of a flower, a withered and disintegrating
dandelion appears, its seeds scattered beside it.
For many people, the dandelion is associated with
childhood memories and the well-known childhood
game – blowing the white fluff off the flowers as
they near the end of their lifecycle and diffusing
their seed to the winds. The withering of the flower
and spreading of its seed also represent the
biological and symbolic beginning of a new life cycle.

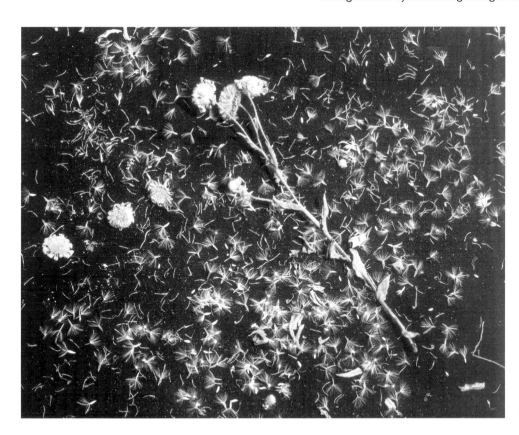

Untitled, 1999,
color print,
40 x 60 in.

LEONARD MEISELMAN | NEW YORK, NY, 1937

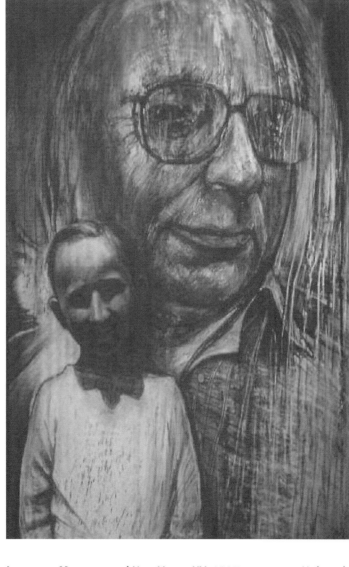

Double Self Portrait, 2003,
oil on canvas,
60 x 36 in.

LEONARD MEISELMAN | New York, NY, 1937
Education: Cranbrook Academy, Michigan, M.A.;
Cooper Union, New York, B.F.A.
Selected Exhibitions: Florence Biennale, Palazzo
Strozzi; Camden Arts Centre, London; Yeshiva
University, New York; Pleiades Gallery, New York

I paint in order to learn. To learn what's inside me.
To learn what connects me to who we are and to
what is important never to forget.

Alicia Milosz | Valenciennes, France, 1953

Education: Cooper Union, New York, B.F.A.

Selected Exhibitions: Winnipeg Art Gallery, Canada; Durham Western Heritage Museum, Omaha, NE; Seibu Department Store, Tokyo; Keihan Gallery, Osaka; University of Maryland, Baltimore; Avampato Discovery Museum, Charleston, WV

I hope that my work attracts you, provokes you, and makes you think. It's about contrasts and similarities, at the same time. Currently, I create portraits in lenticular photography: 2-flip images, that move from one image to the next as you step back and forth. I love the motion of it, and the surprise and amazement it provokes.

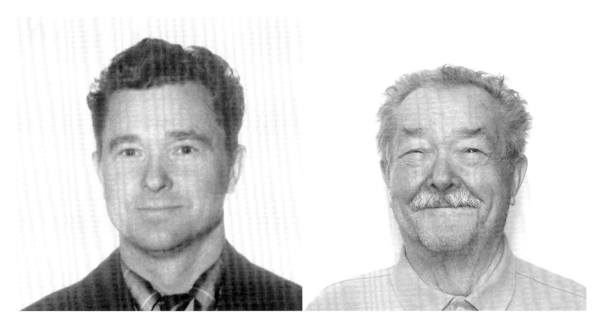

Dad, Age 25 and 77 (detail),
2003, lenticular prints,
24 x 24 in. each

NORMA MINKOWITZ | NEW YORK, NY, 1973

Box, 1993, mixed media object, 8.5 x 8 x 16 in. Courtesy of Bellas Artes Gallery, Santa Fe, NM

NORMA MINKOWITZ | NEW YORK, NY, 1937
Education: Cooper Union, New York, B.F.A.
Selected Permanent Collections: Metropolitan
Museum of Art, New York; National Museum of
Art/Renwick Gallery, Washington, D.C.; Museum of
Arts and Design, New York
Selected Exhibitions: Museum of Fine Arts, Boston;
Yokohama Museum of Art, Japan; Museum of Arts
and Design, New York; Metropolitan Museum of Art,
New York; United States Department of State, Art in
Embassies Program, Warsaw; Smithsonian
Institution, Washington, D.C.

The transparent mesh walls which are crocheted
allow visual access to the interior. Today the body
is not treated as a symbol of beauty but as a complex
and precarious system. The works almost always
convey a feeling of quiet isolation.

RUTH NEVO | JDC-ESHEL, ISRAEL,
SOUTH AFRICA, 1924
Education: English Literature, Ph.D.
Selected Exhibitions: The Debel Gallery, Jerusalem;
Artists House, Jerusalem; Nora Gallery, Jerusalem

Curator's statement: The figures of the elderly drawn by Ruth Nevo are passive, sorrowful images, turned inward and brooding. The woman with the wine cup and sad face creates an atmosphere of loneliness and a dialogue with Impressionist paintings.

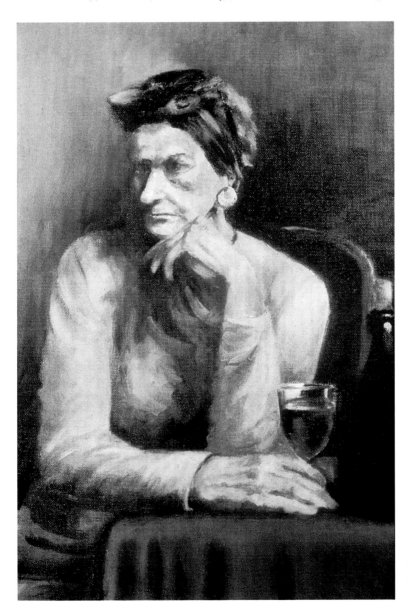

A Glass of Wine,
1987, oil on canvas
18.5 x 14 in.

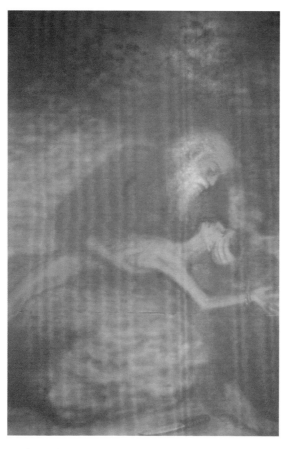

Binding of Isaac, 1984,
spray enamel on canvas,
96 x 65 in.

NATAN NUCHI | ISRAEL, 1951

NATAN NUCHI | ISRAEL, 1951

Selected Permanent Collections: Metropolitan Museum of Modern Art, New York; New York Public Library; Jewish Museum, New York; The Museum of Rhode Island School of Design; New Orleans Museum of Art; Israel Museum, Jerusalem; Haifa Museum; Ramat Gan Museum, Israel; HUC-JIR Museum, New York

Selected Exhibitions: Haifa Museum of Modern Art; New York Academy of Art; Alternative Museum, New York; Klarfeld Perry Gallery, New York; 55 Mercer Gallery, New York; 80 Washington Square Galleries, New York; HUC-JIR Museum, New York

In the Jewish tradition, Isaac is the beginning of a generationally transmitted covenantal relationship — and in the post-Holocaust context, a symbol of the millions sacrificed without hope of redemption, simply because they were Jews or Gypsies or homosexuals or any number of other categories designated for automatic extinction.

Mark Podwal | Brooklyn, NY, 1945

Education: New York University, M.D.; Queens College, New York, B.A.

Selected Permanent Collections: Metropolitan Museum of Art, New York; Victoria and Albert Museum, London; Library of Congress, Washington, D.C.; Carnegie Museum of Art, Pittsburgh, PA; Fogg Art Museum, Cambridge, MA; Israel Museum, Jerusalem; Jewish Museum, New York; National Gallery, Prague; HUC-JIR Museum, New York

Selected Exhibitions: Israel Museum, Jerusalem; Jewish Museum, Prague; HUC-JIR Museum, New York; Forum Gallery, New York; National Museum of American Jewish History, Philadelphia; Jewish Museum, New York; HUC-JIR Skirball Museum, Los Angeles

After my mother died earlier this year, I read and re-read the words of Ecclesiastes which declares that "there is nothing better for man than to rejoice in his own works, since that is his portion. For who can enable him to see what shall be after him?" As an artist, I am able to rejoice in the creative process. Of course, I would be dishonest if I did not admit to trying to cheat death through my work.

And the Dust Returns to the Ground,
Three Studies of Ecclesiastes, 2003, acrylic, gouache, and colored pencil on paper, 10 x 11.5 in. each

PAUL PETER PORGES | VIENNA, AUSTRIA, 1927

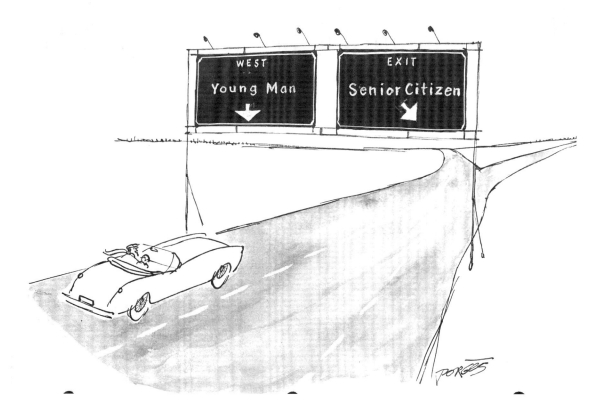

Young Man/Senior Citizen,
ink on paper,
8.5 x 11 in. each

PAUL PETER PORGES | VIENNA, AUSTRIA, 1927
Education: Ecole des Beaux Arts, Geneva; Art
Students League of New York; School of Visual Arts,
New York
Selected Publications: *Saturday Evening Post; The
New Yorker; Mad Magazine*
Selected Exhibitions: The Jewish Museum, Vienna;
HUC-JIR Museum, New York; Christina Ernst Gallerie,
Vienna

DAVID RAPPAPORT | NEW YORK, 1914
Selected Exhibition: Taller Boricua Gallery at Julia De Burgos Culture Center, New York

After retirement from the fashion industry, David Rappaport studied at the Art Students League. When he suffered a severe stroke at the age of 85 that rendered his right hand useless, he learned to paint with his left hand.

Nightfall, 2002, acrylic on canvas, 16 x16 in.

HAVA RAUCHER | JDC-ESHEL, ISRAEL, BULGARIA, 1944

Education: Washington University, St. Louis, MO, M.F.A.

Selected Permanent Collections: Evansville Museum of Arts and Science, IN

Selected Exhibitions: National Art Center, Soho, NY; N.A.M.E Gallery, Chicago, IL; Artists House, Jerusalem; Israeli Artists in Moscow, Russia

Curator's statement: The mature body of the nude Eva, facing the viewer, reveals the remnants of beauty that has passed. Her thighs, once svelte, are now laced with distended veins, her ample breasts have fallen and her arms dangle. The model leans uncomfortably. She appears suspended in space, disconnected from her surroundings and unaware of the sorry state of nudity of her body.

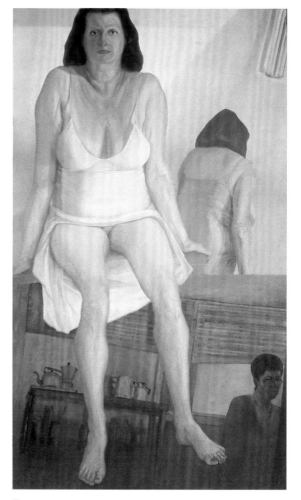

Eve, 1977,
oil on canvas,
72 x 54 in.

Sampler (DNA) (detail), 2002,
embroidery on linen,
14.5 x 58 in.
Courtesy of Shoshanna Wayne Gallery,
Santa Monica, CA

ELAINE REICHEK | NEW YORK

Education: Yale University, New Haven, CT, M.F.A

Selected Exhibitions: Museum of Modern Art, New York, NY; Palais des Beaux-Arts, Brussels; Tel Aviv Museum; Jewish Museum, New York

The artist's project addresses creation in the most literal sense, but it also explores reproduction, replication, and the simultaneous persistence and transformation of our ideas of creation and genesis as technologies and artistic methods change.

DEBORAH ROSENTHAL | NEW YORK, 1950

Gravestone of the Old Couple, 2002, oil, pastel on linen, 21 x 28 in.

DEBORAH ROSENTHAL | NEW YORK, 1950
Education: Pratt Institute, New York, M.F.A.; Barnard College, New York, B.A.
Selected Permanent Collections: Bryn Mawr College, PA; Rider University, Lawrenceville, NJ; Philadelphia Museum of Jewish Art
Selected Exhibitions: HUC-JIR Museum, New York; Bowery Gallery, New York; Yeshiva University Museum, New York; University of Connecticut, Bronfman Gallery, JCC of Washington, D.C.

My painting, *Gravestone of the Old Couple,* is a memory portrait of my late parents, a memorial to their long marriage. I think of them here particularly as they were as an old couple, fascinated as always by each other, having great joy in being together, arguing literature together as they always had. The composition evokes an ancient Roman sarcophagus for a married couple, its seemingly incised trajectories binding the profile and full-face views of the two spouses into an endless unity.

Barbara Rothenberg | New York, NY, 1933

Education: Columbia University Teacher's College, New York, M.A.; University of Michigan, Ann Arbor, B.A.

Selected Permanent Collections: United Nations, New York; Chase-Manhattan, New York; Citibank, New York; General Electric Headquarters, Fairfied, CT; Smithsonian Institution, Washington, D.C.

Selected Exhibitions: United Nations, New York; Discovery Museum, Bridgeport, CT; Connecticut Commission on the Arts, Hartford, CT; Gallery Brocken, Koganei, Japan

The image of the fern as my subject has been evolving during the last stages of my mother's illness. Fern Fading is a final image in that cycle. As a painter drawn to abstracting from nature, I see the fern and its skeletal form, as a metaphor for the human body.

Fern Fading
What fades, renews
Rebounds, re-seeds
And, in another season
Can be found

Here, Time is neither up nor down
But round

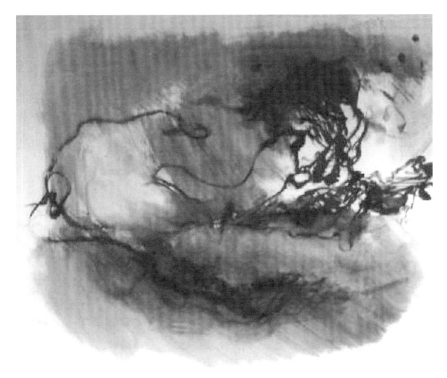

Fern Unfurling, 1997,
sumi ink on paper,
12 x 15 in.

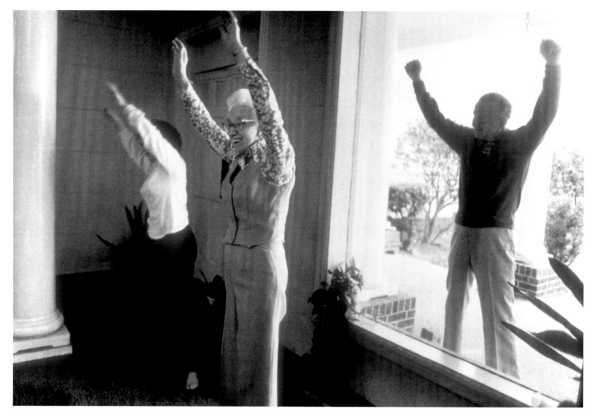

Family Exercise Class, 1982, gelatin silver prints, 8.5 x 13 in. each

JANICE RUBIN | FAIRBORNE, OHIO, 1955
Education: Rice University, Houston, B.A.
Selected Permanent Collections: Houston Museum of Fine Arts; Amon Carter Museum, Fort Worth, TX
Selected Exhibitions: Cooper-Hewitt Museum of Design, New York; Museum of Fine Arts, Houston; Holland Foto/Muziektheater, Amsterdam

I have always used my camera as a tool to explore the world. Recently I have focused on Jewish family, ritual, and rites of passage. My camera became the unobtrusive observer as cousins, aunts, uncles and grandparents shared stories, songs, gift-giving, eating, and quirky family traditions. I believe that these photographs express the existence of the deep emotional bonds between the generations.

JANICE RUBIN | FAIRBORNE, OHIO, 1955

JONATHAN SANTLOFER | NEW YORK, NY, 1947

Education: Pratt Institute, Brooklyn, NY, M.F.A;
Boston University, B.A.

Selected Permanent Collections: The Art Institute
of Chicago; The Norton Simon Museum, Pasadena,
CA; The Grand Rapids Art Museum, MI; The
Indianapolis Museum of Art, IN

Selected Exhibitions: Graham Modern Gallery, NY;
Galleria Peccolo, Livorno, Italy; The Institute of
Contemporary Art, Tokyo, Japan; Betsy Rosenfield,
Klein Gallery, Chicago, IL

I don't think I would have been able to make these
paintings when I was young. The fact is I was not
particularly interested in the subject matter of family
history until I was older, and had some perspective.
Now, the idea of exploring one's personal history
and legacy, and attempting to make it universal,
seems both natural and inevitable.

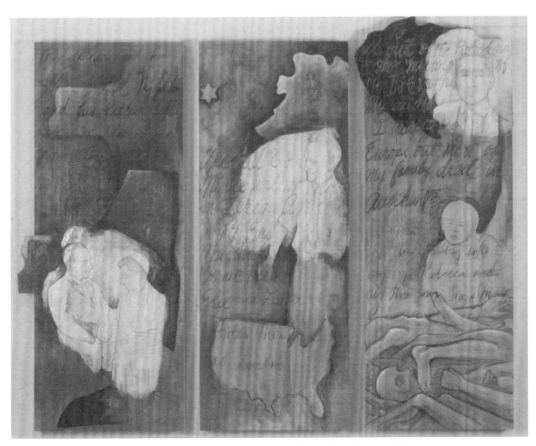

The Men's Story, 1996-1997, triptych, mixed media on wood, each work 80 x 96 in.

DEIDRE SCHERER | NEW YORK, 1944

Education: Rhode Island School of Design, Providence, RI, B.F.A.

Selected Permanent Collections: Baltimore Museum of Art; Dartmouth College, Hanover, NH; Museum of Science, Boston; Art in Embassies, U.S. State Department, Brussels

Selected Exhibitions: Museum of Arts and Design, New York; Helsinki; Museum of Fine Arts, Springfield, MA; Alexandra Palace, London; United Nation Conference on Women, Nairobi

As the aging face has become my most significant subject matter, it gives me particular joy to make the elders and the mentors more visible and accessible. Images of aging have the power to influence social change by aesthetically and psychologically challenging ageism. Repeatedly I am drawn to the detailed and pointillistic patterning of cloth. Fabric has become the perfect vehicle with which to translate elements that are complex, non-verbal, and even invisible.

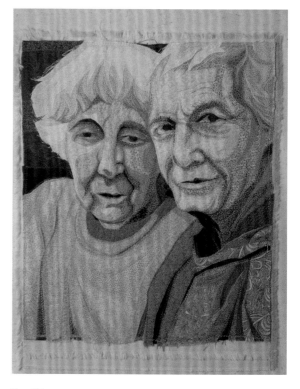

Two Women,
Fabric and thread,
28 x 24 in.
Collection of the artist

DEIDRE SCHERER | NEW YORK, 1944

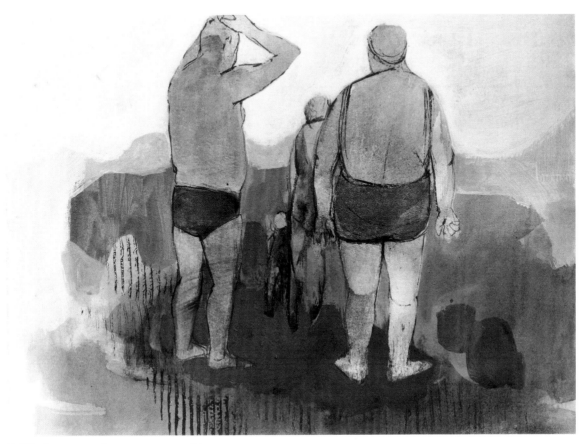

Untitled, 1995, acrylic on paper, 13 x 16 in.

RUTH SCHLOSS | JDC-ESHEL, ISRAEL, GERMANY, 1922
Education: Bezalel Academy of Art and Design, Jerusalem
Selected Permanent Collections: Israel Museum, Jerusalem; Land of Israel Museum, Tel Aviv; Pushkin Museum, Moscow; Wichita Museum, KS
Selected Exhibitions: Cité des Arts, Paris; The American-Israeli Cultural Center, New York; Beit Gavriel, Zemach, Israel; Israel Museum, Jerusalem

Curator's statement: The work of Ruth Schloss that deals with the elderly and scenes from an old age home is related to a period in which the artist would visit her elderly mother and her mother's friend in a nursing home. Several aspects of old age are evident in these paintings – both softness and optimism, expressed by the old people bathing and exercising on the beach, smoking and raising pets; as well as gloom, a sense of no exit from the crowded nursing home room – the chronically ill ensconced here, deep within themselves, and bereft of hope.

Ivan Schwebel | West Virginia, 1932
Education: New York University
Selected Permanent Collections: Brandeis University, Waltham, MA; Ben Gurion University of the Negev, Israel; Mann Auditorium, Tel Aviv; Azrieli Mall, Jerusalem

Schwebel reflects on the land of Israel, its society, and politics. The reflections grow in power as the Bible makes the journey from Jerusalem to New York.

Shwebel responds to his environment – whether the Judean hills, Jerusalem, Tel Aviv, or New York, which has become a major force in his painting. He combines actual modern day surroundings with biblical interpretations, drawing on his personal experience – bringing King David into contemporary situations as if there are dire truths that the King must encounter now, today, as he did in the Books of Samuel and Kings.

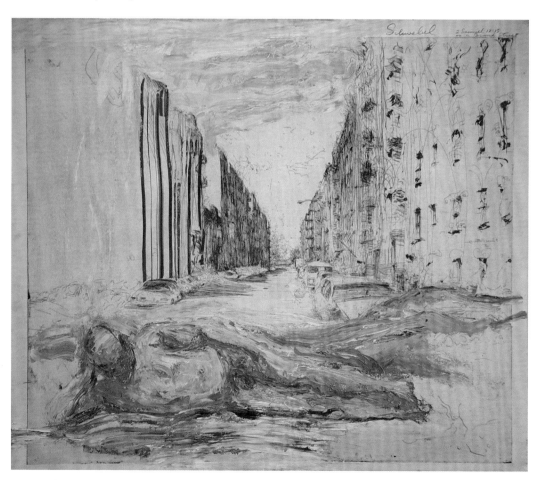

2 Samuel 12:15 on a Bronx Street, 1990, oil on canvas, 28 x 33 in.

Ivan Schwebel | West Virginia, 1932

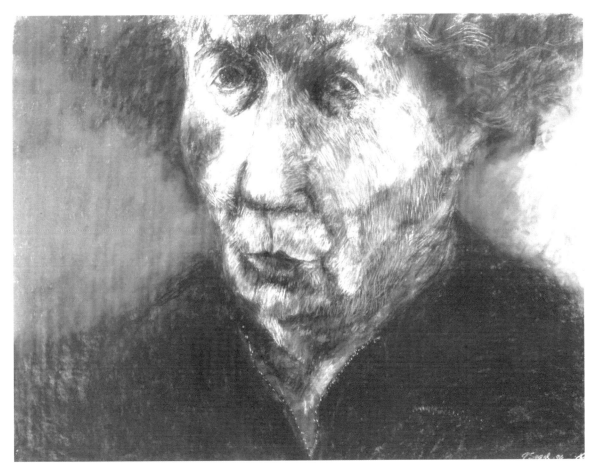

Helen V, 1996, pastel on paper, 38 x 50 in. Courtesy of the George and Helen Segal Foundation, Carroll Janis, Inc.

GEORGE SEGAL | NEW YORK, NY, 1924-2000

Education: Rutgers University, Trenton, NJ, M.F.A.; Pratt Institute, New York, B.S.

Selected Permanent Collections: Jewish Museum, New York; Guggenheim Museum, New York; Whitney Museum of American Art, New York; National Gallery of Art, Washington, D.C.; San Francisco Museum of Modern Art; Hirshhorn Museum and Sculpture Garden, Washington, D.C.

Selected Exhibitions: Jewish Museum, New York; Galerie Ileana Sonnabend, Paris; Museum of Contemporary Art, Chicago; Israel Museum, Jerusalem; Tel Aviv Museum; Skirball Museum, Los Angeles; Bronfman Museum, Montreal; Zimmerli Art Museum, Rutgers University, Trenton, NJ; IFSI, Paris

Changing, 1999,
oil on canvas,
30 x 24 in.

GIDEON SHACKNAI | JERUSALEM, 1931

GIDEON SHACKNAI | JERUSALEM, 1931
Education: Columbia University, New York; City College of New York, B.A.
Selected Exhibitions: Monserrat Gallery, New York

My paintings reflect my interest in the universe and its ever-changing nature. I am constantly searching for the essence of an object or an idea that can transcend what we consider reality and change it to express its universal meaning. Through my use of color, brush stroke and composition, I strive to express universal meaning. My organic approach to painting allows me to explore my ideas through my paintings.

Laura Lazar Siegel | New York, NY, 1938
Education: Columbia University, New York, M.F.A.;
Pratt Institute, New York, B.F.A.
Selected Permanent Collections: Texaco
Corporation; Aetna Insurance Company
Selected Exhibitions: HUC-JIR Museum, New York;
Bronfman Gallery, JCC of Washington, D.C.; University
of Connecticut

To Life is a celebration of life. The work is
conceptualized by a collage of my husband's mother
surrounded by three generations of family. The
images form a *kiddush* cup of life. The *shehechyanu*
prayer, blessing God for allowing us to reach this
time, encircles the cup. Patterns of interlocking
circles represent life cycles. An *etz chaim* of trunk-
shapes intersects with the forms. Images of grapes
evoke sustenance and wine. A bird represents the
human spirit, our imaginations, and flight into the
unknowable.

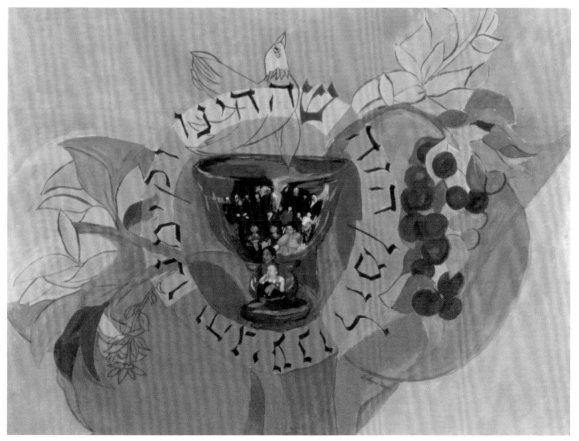

To Life, 2003, acrylic on paper, 22 x 30 in.

ROBBIN AMI SILVERBERG | BOSTON, MA, 1958

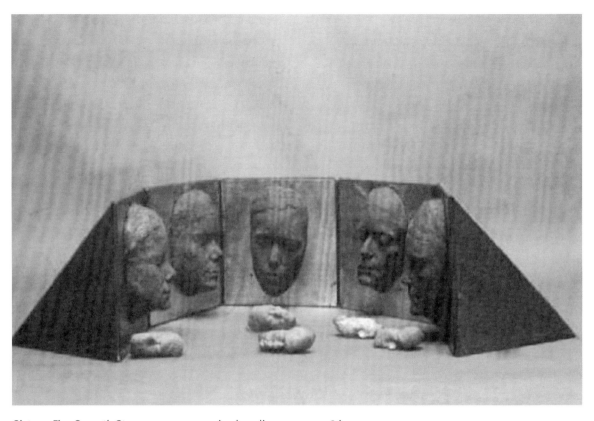

Sisters: Five Smooth Stones, 1992-1993, mixed media, 22 x 22 x 28 in.

ROBBIN AMI SILVERBERG | BOSTON, MA, 1958
Education: Princeton University, NJ, B.A.
Selected Permanent Collections: National Museum of African Art, Washington, D.C.; Museum of Fine Arts, Budapest; Technikon Natal Art Gallery, Durban, South Africa; Yale University, New Haven, CT
Selected Exhibitions: Jewish Museum of Maryland, Baltimore; La Galleria – Haus der Kunst, Guadelahara, Mexico; Center for Book Arts Gallery, New York; Rosenwald Gallery, University of Pennsylvania, Philadelphia; Brooklyn Public Library Gallery, New York; HUC-JIR Museum, New York

This collaborative artist book, which is a five-part box structure, consists of two sets of cast paper heads and five texts, each different translations of I Samuel 17:40. The text describes the moment that David approaches Goliath and chooses five smooth stones to throw, one of which will reach its goal. The heads are life castings of five actual sisters, which were then shrunk, the small set looking much like "five smooth stones." *Sisters* explores the constellar relations between siblings, place, and time.

Kiki Smith | Nuremberg, Germany, 1954

Selected Permanent Collections: Museum of Modern Art, New York; Whitney Museum of American Art, New York; Victoria and Albert Museum, London; Art Institute of Chicago; University of Michigan Museum of Art, Ann Arbor; St. Louis Art Museum; Tate Gallery – Modern, London

Selected Exhibitions: Whitney Museum of American Art, New York; World House Gallery, New York; International Print Center, New York; Nohra Haime Gallery, New York; Exit Art/The First World, New York; CRG Gallery, New York; Museum of Modern Art, New York

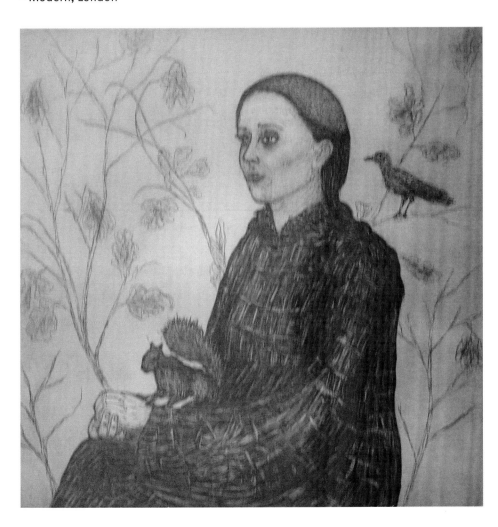

Fall, 1999 etching 22 x 15 in. each Courtesy of the Rutgers Center for Innovative Print and Paper, New Brunswick, NJ

Kaddish for Lilly,
1999,
oil, acrylic, papier
maché on canvas,
24 x 36 in.

JOAN SNYDER | HIGHLAND PARK, NJ, 1940

JOAN SNYDER | HIGHLAND PARK, NJ, 1940
Education: Rutgers University, Trenton, NJ, M.F.A.;
Douglass College, Rutgers University, Trenton, NJ,
B.A.
Selected Permanent Collections: Allen Memorial
Art Museum, Oberlin College, OH; Corcoran Gallery
of Art, Washington, D.C.; Dallas Museum of
Contemporary Art; Fogg Art Museum, Harvard
University, Cambridge, MA; Jewish Museum, New
York; Metropolitan Museum of Art, New York;
Museum of Fine Arts, Boston; Museum of Modern
Art, New York; Whitney Museum of American Art,
New York

Selected Exhibitions: Nielsen Gallery, Boston;
Philadelphia Museum of Jewish Art; Brooklyn
Museum of Art, New York; Rose Art Museum,
Brandeis University, Waltham, MA; HUC-JIR Museum,
New York

I made this painting for a woman named Lilly who
was once a close friend of mine. She was a therapist,
a great lover of opera, and a Holocaust survivor. Lilly
was a very complex person who over the course of
years antagonized almost everyone she knew. I made
this painting for her because when she died I worried
that no one had said *Kaddish* for her. And so this is
Kaddish for Lilly.

ANN SPERRY | BRONX, NY

Education: Sarah Lawrence College, Riverdale, NY, B.A.

Selected Permanent Collections: Tel Aviv Museum; Library of Congress, Washington, D.C.; Bibliothèque Nationale, Paris; Getty Collection, Los Angeles

Selected Exhibitions: HUC-JIR Museum, New York; Honen-in Temple, Kyoto; Hudson River Museum, New York; Neuberger Museum at SUNY Purchase, New York; New Museum of Contemporary Art, New York

My father bought me a Sohmer spinet. When my father died I discovered that he had bought the piano on time, and had spent 10 years paying it off. He never told me. Following my mother's death I lent the piano to friends. Many moves over many years amid temperature and humidity changes created so much damage it was apparent that repairs and reconstruction were not possible. Over a period of 11/2 years, I disassembled the piano, collecting boxes of piano parts as well as the mahogany case. My Piano 22 is the final piece in the My Piano series of sculptures made of these parts and other odd metal shapes.

I wanted my father's voice to be heard in these pieces, but as I was working on them I realized I also wanted to have a dialogue with him. He died when I was 15 1/2, so I never had a chance to really speak to him as an adult.

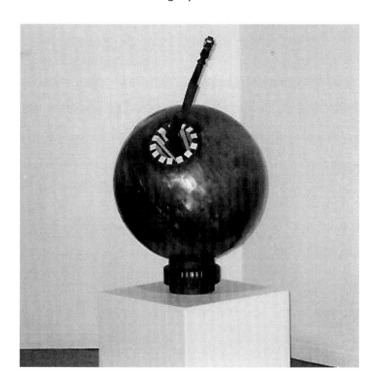

My Piano 22, 2003,
wood, metal, ivory,
39 x 24 x 24 in.
Courtesy of Kraushaar Gallery,
New York

Family Values, 1993,
The New Yorker cover

ART SPIEGELMAN | STOCKHOLM, SWEDEN, 1948

ART SPIEGELMAN | STOCKHOLM, SWEDEN, 1948
Education: SUNY Binghamton, NY, B.A.
Selected Exhibitions: Museum of Modern Art, New York; Jewish Museum, New York

Selected Publications: *The New York Times; Playboy; The Village Voice; Raw,* co-founder/editor
Selected Books: *Maus I: A Survivor's Tale; Maus II: Open Me....I'm a Dog; The Wild Party,* illustration

Melissa Stern | Philadelphia, PA, 1958

Education: State University of New York at New Paltz, M.F.A.; Wesleyan University, Middletown, CT, B.A.

Selected Permanent Collections: Dow Jones & Co., Inc., New York; Bear Stearns & Co., New York; Metropolitan Home Magazine Design Collection, New York; Kohler Company Collection, Sheboygan, WI

Selected Exhibitions: Children's Museum of the Arts, New York; Atelier X, Brussels; Art Rages, Amsterdam

This drawing was inspired by the senior class photograph in a 1950's high school yearbook. It looks back through time at an ever-changing portrait of one's self and one's contemporaries:
The faces recalled with delight.
The friends and acquaintances lost by memory or by fate.
Those remembered or abandoned by time. The class reunion in each of our minds.

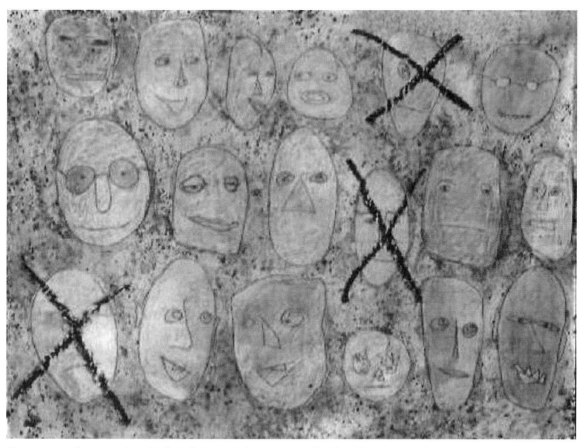

Class, 2003, oil, encaustic, mixed media, 27 x 30 in. Courtesy of Lusk Gallery, New York

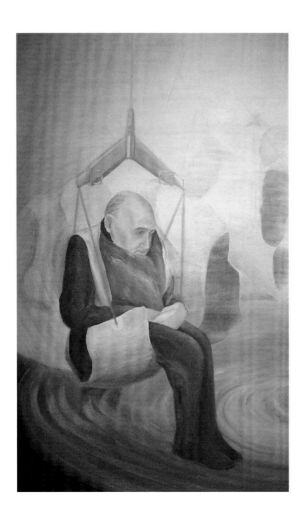

Carousel (detail), 1999,
oil on canvas,
48 x 60 in.

MIRIAM STERN | NEW YORK, NY, 1946

MIRIAM STERN | NEW YORK, NY, 1946
Selected Permanent Collections: Yeshiva University,
New York; Hunterdon Art Museum, Clinton, NJ;
Kibbutz Yahel, Israel
Selected Exhibitions: HUC-JIR Museum, New York;
University of Connecticut; Bronfman Gallery, JCC of
Washington, D.C.

This series of paintings expresses my personal
struggle with my father's illness and decline. In the
privacy of my studio I transform my anguish by
equating his current situation to the experience of
being on a ride in an amusement park. Like him, we
are moved about without our control when riding a
carousel or Ferris wheel.

This use of black humor enables me to deal with
this awful and frightening situation that I must
confront with each visit.

Sergei Teryaev | JDC-Eshel, Israel, USSR, 1952

Education: Krasnoyarsk Art School, USSR

Selected Exhibitions: Actors' House, Krasnoyarsk; Artists House, Jerusalem; Exhibition of watercolors, Moscow; "Art London 90", Olympia Hall, London

Curator's statement: The works of Sergei Teryaev present the elderly playing golf and feeding birds from a park bench. Both reveal the effort required of the old person. In the golf game, the figure in the back stoops over to place the ball prior to hitting it, while leaning his entire weight on the stick. In *Loneliness*, the physical strain of the old person is evident, sitting on a bench and leaning forward to scatter crumbs for the birds.

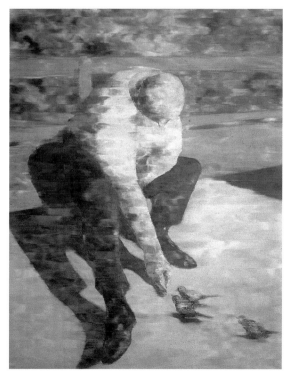

Loneliness, 1999,
oil on canvas
44 x 36 in.

Wisdom/Memory, 2003,
metal, height 20 x diameter 14 in.

JONATHAN WAHL | ABINGTON, PA, 1968

JONATHAN WAHL | ABINGTON, PA, 1968
Education: State University of New York, New Paltz, M.F.A. in metal; Temple University, Tyler School of Art, Elkins Park, PA, B.F.A.
Selected Permanent Collections: Museum of Arts and Design, New York; Samuel Dorsky Museum of Art, SUNY, New Paltz, NY
Selected Exhibitions: Museum of Arts and Design, New York; New York State Museum, Albany; Richard Anderson Fine Arts, New York; Samuel Dorsky Museum, New Paltz, NY; Seibu Department Stores, Tokyo

By re-inventing in the historical manufacture of tin objects I am attempting to create in my work the experience of irony and contradiction found in the reality of American life in comparison to its ideals. It is my endeavor to re-contextualize these functions of early American tin ware by altering or subverting their function with functions that convey my political agenda. In doing so it is my aim to create a "new reality" or understanding of those forms through an infusion of the ideals that were integral to their development with issues that are confronting our society today.

Joyce Ellen Weinstein | New York, NY, 1940
Education: The City College of New York, B.A., M.F.A.
Selected Permanent Collections: HUC-JIR Museum, New York; Gallerie-Junge KunstWerkStart, Vienna; National Museum of Women in the Arts, Washington, D.C.
Selected Exhibitions: HUC-JIR Museum, New York; University of Connecticut; Bronfman Gallery, JCC of Washington, D.C.

All humans die regardless of whether they have been virtuous or base in their lives. All humans attempt to forestall old age and death one way or another. *Behold Thy Days Approach: The Death of Moses* is about the biblical story of Moses's relationship to God and metaphor for the certainty of the human condition.

Behold, Thy Days Approach, 2003,
mixed media,
18 x 13 in.

Initiation, 1997,
drawing on paper, 44 x 22 in.
Collection of Judith Resnick
and Dennis Curtis

RUTH WEISBERG | CHICAGO, IL, 1942

RUTH WEISBERG | CHICAGO, 1942

Education: University of Michigan, Ann Arbor, M.A., B.A.

Selected Permanent Collections: Bibliothèque Nationale, Paris; Instituto Nationale per la Grafica, Rome; Los Angeles County Museum of Art; Metropolitan Museum of Art, New York

Selected Exhibitions: HUC-JIR Museum, New York; Art Institute of Chicago; Metropolitan Museum, New York; National Gallery, Washington, D.C.; Fine Arts Museum, San Francisco; University of Connecticut; Bronfman Gallery, JCC of Washington, D.C.

From my vantage point it appears that "Le temps n'a point de rives (time is a river without banks)" has both a subjective and synchronic quality, rooted in Jewish ideas concerning time and memory.

ALLAN WINKLER | CHICAGO, IL, 1953

Selected Permanent Collections: Hallmark Cards, Kansas City, MO; Sterling Jewelry Corporate Office, Akron, OH; Richard J. Daley Library, Chicago

Selected Exhibitions: Chicago Public Library Cultural Center; Philadelphia Art Museum; Alaska State Museum, Juneau, AK

You asked me why I make paper cuts. Well, I could say that I enjoy making them, but the truthful explanation is that I'm good at it. For some unknown reason I am able to take a blank piece of paper and using a sharp blade, I just start cutting with no clear idea of what will be created. I chip away at the paper removing piece after piece and the picture comes to life. I feel that these images are being created through me—I am not in charge. When I am done I am always surprised at the final image.

Old Man with Hat, 2003,
paper-cut,
24 x 18 in.

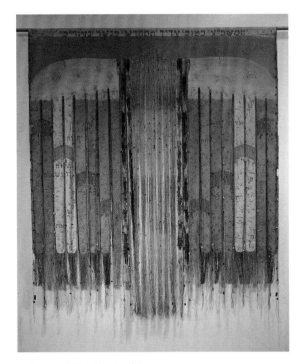

...Renewed like the Eagle's, 2003,
textile, mixed media,
64 x 60 in.

LAURIE WOHL | WASHINGTON, D.C., 1942

LAURIE WOHL | WASHINGTON, D.C., 1942
Education: Columbia Law School, New York, L.L.B.;
Sarah Lawrence College, Bronxville, NY, B.A.
Selected Permanent Collections: Museum of Arts
and Design, New York; Beverly Art Center, Chicago;
United States Embassy, Tunis, Tunisia, Pretoria,
Capetown, South Africa, Vienna, Austria, and Beirut,
Lebanon; American Bible Society, New York
Selected Exhibitions: Wisconsin Lutheran College,
Milwaukee; Catholic Theological Union, Chicago;
Indianapolis Arts Center; HUC-JIR Museum, New
York; HUC-JIR Skirball Museum, Cincinnati

I hope in this textile piece to celebrate the
possibilities for strength, renewal, and acceptance
as we age, along with the possibilities for delight in
the sacredness of each moment. My technique,
removing threads to shape a form, evokes an
emptying of the self for meditation and
contemplation. The piece is "rewoven" with color,
Hebrew calligraphy, and my own narrative
iconography. This unweaving is inspired particularly
by Psalm 10:5-6 "...who satisfies thy old age with
good; so that thy youth is renewed like the eagle's."

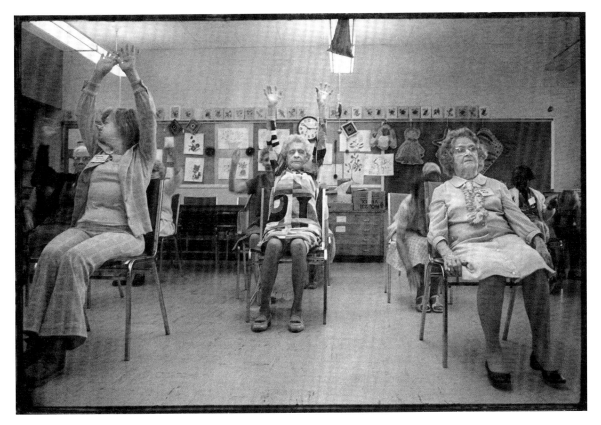

Exercise Class, Madison Center, Arlington, VA, 2002, photograph, 16 x 22 in.

LLOYD WOLF | DAYTON, OH, 1952

Education: Goddard College, Plainfield, VT, M.A.; Trinity College, Hartford, CT, B.A.

Selected Permanent Collections: Corcoran Museum, Washington, D.C.; National Museum of Fine Arts, Hanoi, Vietnam; Library of Congress, Washington, D.C.; Museum of Jewish Heritage, New York

Selected Exhibitions: Washington Center for Photography, Washington, D.C.; HUC-JIR Museum, New York; University of California, ASUC Studio, Berkeley; Washington Project for the Arts, Washington, D.C.; American University of Cairo

This photograph was taken during an exercise session of a senior day care program located in the Madison Community Center in Arlington County, Virginia. It was part of a National Endowment for the Arts grant I received to document Arlington with my colleague Paula Endo.

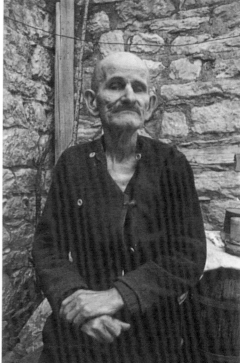

Yugoslavia, 1971, photograph, 17 x 22 in.

DONALD WOODMAN | HAVERHILL, MA, 1945
Education: University of Houston, M.F.A. in photography; University of Cincinnati, B.S. in architecture
Selected Permanent Collections: Museum of Art and History, Fribourg, Switzerland; Polaroid Collection, Polaroid Corp, Cambridge, MA; Victoria and Albert Museum, London; New Orleans Museum of Art
Selected Exhibitions: Yeshiva University Museum, New York; Florida Holocaust Museum, St. Petersburg, FL; Spertus Museum, Chicago

In 1971 I spent two weeks traveling through Yugoslavia, which had only two paved roads, both running north/south, one in the center of the country and the other along the coast. I came across this scene in an isolated mountain village where there was very little or no vehicular travel and no electricity. The air was so still and quiet that one could hear the songs of distant herders wafting through the air as they sang to their animals. This exhibition provides a perfect venue for this sequence of images.

Itzhak Yamin | JDC-Eshel, Israel, Iraq, 1938

Education: Bezalel Academy of Art and Design, Jerusalem

Selected Exhibitions: Khoushi House, Haifa; Bergman Gallery, Tel Aviv; Artists House, Jerusalem; Amsterdam, Holland

Curator's statement: Itzhak Yamin's work, which yearns toward the past, evokes memories from his parents' home. Assorted objects appear that are no longer useful – bedding, musical instruments, embroidered and woven tablecloths, a letterbox, and a pack of letters tied with a red silk ribbon. A creased letter lies open on the table, written in round, innocent script. Enamel kettles are piled up, and a bitten hamburger sandwich lies there, a reference to the contemporary fast-food industry, juxtaposed with the cooking utensils of mother's kitchen.

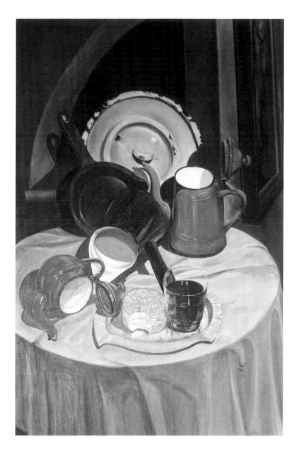

Tools from My Father's Home, 1997, oil on canvas, 35 x 24 in.

Bebe Yannay | Kaunas, Lithuania, JDC-Eshel, Israel

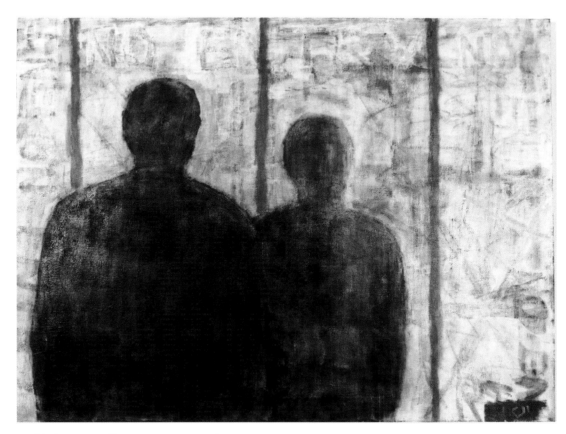

Untitled, 1991, acrylic on canvas, 28 x 39 in.

Bebe Yannay | JDC-Eshel, Israel, Kaunas, Lithuania
Education: Private study with selected teachers, Jerusalem; Avni Institute of Fine Arts, Tel-Aviv
Selected Exhibitions: Edison Gallery, Den Hague; Bronfman Museum, Montreal; Art Centers, Mexico and Latin America; Salon des Beaux-Arts, Grand Palais, Paris; Nora Gallery, Jerusalem; Artists House, Jerusalem

Curator's statement: The drawings suggest circumstances of forgetting, the erasing of memory and of connection to objects, places, and one's surroundings. Sometimes lines appear in the background, a kind of aid to help place the figures and anchor them in the space of the picture. Faded, erased words also appear in the background, a kind of directional signal to connect between the figures and their location and situation.

Barbara Zucker | Philadelphia, PA

Education: Hunter College, New York, M.A.; University of Michigan, Ann Arbor, B.S.

Selected Permanent Collections: Reader's Digest Foundation; Philadelphia Museum of Art; Whitney Museum of American Art, New York; Chase Manhattan Corporation

Selected Exhibitions: Pennsylvania Academy of Fine Art, Philadelphia; Queens Museum of Art, New York; New Museum of Contemporary Art, New York

Time Signatures is a series based on wrinkles in the faces of women. These lines or patterns are analogous to the meandering paths that rivers cut through the land, and to the crackled surface of the earth in times of drought. When taken out of their usual context, the fine tracery of lines on a face is a beautiful part of nature. In our youth-driven culture however, it is difficult to see the evidence of a long life as anything but a loss. These sculptures began as self-portraits – if I could make something positive out of my own struggle with aging, perhaps I could come to terms with it. Soon after, I realized I wanted to pay tribute to women in history I admire who have made a significant contribution to the culture. I have also explored the faces of unsung women as well as the faces of friends. These decisions have provided me with a rich and seemingly endless source of inspiration

Time Signatures: Golda Meir, 2002, laser-cut steel, 17.5 x 21.25 x 1.5 in.

SIGMUND ABELES
Who Can Forget How Blue the Sky Was Beforehand, 2001,
oil on canvas, diptych,
60 x 34 in. each

RORY ALLWEIS
Where Are My Dreams, 1992,
oil on canvas, 35 x 46 in.

ELEANOR ANTIN
Recollection of My Life with Diaghilev, 1919-1929 by Eleanora Antinova, 1981,
tinted silver gelatin print set,
14 x 11 in. each
Before the Revolution L' Esclave Prisoner of Persia
The Hebrews Courtesy of Ronald Feldman Fine Arts,
New York

ALIZA AUERBACH
silver gelatin print,
24 x 20 in. each
Chaim Feldner,Bet Alpha
Moshe Surkin, Ein Harod
Gedalia Shefer, Yavneel
Aryeh Gilad, Kfar Vitkin

SAMUEL BAK
Old Man' s Departure, 1977,
charcoal, chalk on paper,
24.75 x 19 in.
Courtesy of Pucker Gallery,
Boston

MARILYN BANNER
Flight of Time/Life Passages,
2002, fabric, 12 panels,
54 x 9.5 in. each

MARK BERGHASH
The Age Hurdle, 2001,
1/4, gelatin silver print,
triptych, 16 x 20 in. each
Disintegration, Polaroid and wet transfer images, 11 x 14 in.

DEVORA BERTONOV
Making Way for a Green Leaf,
documentary film with Devora Bertonov by Ayana Friedman,
2000, 12 min.

TAMI BEZALELI-SHOHET
Man, 2000, acomeh wood,
24 x 9 x 11 in. *Woman*, 1997,
mahogany wood,
25 x 12 x 10 in.

HYMAN BLOOM
*Old Woman in Red,*1957/2003,
oil on canvas, 55.5 x 42 in.

ANDRÁS BÖRÖCZ
Draftsman: The Funeral, 2001,
mixed media,
12.75 x 7.75 x 4.2 in.
Courtesy of Adam Baumgold Gallery, New York

YAEL BRAUN
Goodbye My Dear, I am Off, 1977,
sepia ink on paper, 25 x 15 in.
Grandfather and the Birds, 1978,
oil pastel on brown paper,
20 x 13 in.
My Grandparents at the Graveyard, 1999, oil on canvas,
20 x 20 in.

ROBERT BRONER
Unbounded Space, 2002,
water color on paper, 4 paintings,
15 x 12 in. each

MARILYN COHEN
A Walking Tour of an American Life: A Work in Six Acts, 2001,
water color dyed torn paper collage, acrylic on canvas,
6 panels, 16 x 12 in. each

ROBI COHEN
Growing Distance, 2000,
oil on canvas, 28 x 34 in.

JULIE DERMANSKY
Jacqueline Bouvier Kennedy Onassis Totem, 2003, steel, mixed media, 86.5 x 8 x 12.5 in.

DAVID DEUTSCH
What Goes Around Comes Around, 1999, oil on canvas,
45 x 60 in.

MARY REGENSBERG FEIST
Mary and Leonard, 2000,
oil on canvas, 24 x 30 in.

MAX FERGUSON
Doll Hospital, 2003,
graphite on paper, 18 x 12 in.
Courtesy of ACA Gallery,
New York

LARRY FINK
Whisper Project: Minneapolis, Minnesota, silver gelatin print,
20 x 16 in. each
Women in Mirror, January, 1987
Clasped Hands, March, 1987

AUDREY FLACK
Portrait of Mother, 2003,
composite plaster
12 x 8 x 8 in.

Paul Fux
Passages, 1988, mixed media, 11.5 x 15 in. *Self Portrait,* 1998, ink and acrylic on paper, 14 x 10 in. *Untitled,* 1989, oil on canvas, 12 x 14 in.

Mort Gerberg
ink, graphite on paper
Don't Knock Florida, 11 x 8.5 in.
Half a Pound of Pain and Anguish, 14 x 11 in.
Heritage Acres..., 1981, 11 x 9 in. *I Understand She's Marrying Him,* 8 x 11 in.
Nathan Just Realized, 8.5 x 11 in.
So What Do You Think, Howie, 11 x 8 in.
Stop Kvetching, 8 x 11 in.
The Children are Coming, 11 x 13.75 in
This Seat Reserved, 8 x 11 in.
Your Old Jewish Mother, 8 x 11 in.

Janet Goldner
Honor, Celebrate..., 1993, welded steel, 33 x 19 x 22 in.

Grace Graupe-Pillard
Evening, 1990, porcelain enamel on metal, 24 x 24 in.

Samuel H. Gross
Dorian Gray, 1980, ink on paper, 14 x 11 in.
It's Meals on Wheels, Mrs. Hokenstadt, 1992, 14 x 11 in.
Rosebud, 1989, 14 x 11 in.
The Old Boy Network, 1989, 14 x 11 in.

Maty Grünberg
Aging: The State of Israel, 2003, ink on paper, 20 x 61 in.

Karen Gunderson
Me & Me & Tulips in Time, 2003, oil on canvas, 48 x 58 in. Courtesy of Julian Weissman Fine Arts, New York

Carol Hamoy
Six Months, 2002, mixed media, 10.5 x 47.5 x 0.75 in.

Hanan Harchol
Witnessing Sacrifice, 2003, multi-media, 116 x 96 x 26 in.

Judah Harris
Azalea, 1987, photography, 13 x 9 in.

Sidney Harris
But When You Live, ink on paper, 14 x 10.5 in.
My Inner Child, 14 x 11 in.
Our Reputation for Longevity, 14 x 11 in.

Ellen Harvey
ID Card Project, 1998. oil on Masonite, 25 panels, 7 x 5 in. each. Collection of Linda and John Farris

Frances Heinrich
Just Passing Thru, 1997, photo/graphite drawing, diptych, 7 x 9 in. each

Albert Hirschfeld
lithograph, hand signed, limited edition *Self Portrait as Inkwell, The Artist at 95,* 1997, 126/195, 17 x 19 in.
Self Portrait, 99 Years, 2002, 73/299, 17.5 x 19.5 in.
Courtesy of Margo Feiden Gallery, New York

Edith Isaac-Rose
Dolls Dress for Battle, 2003, mixed media, water color, ink, 13.75 x 11 in. each

Jane Joseph
Hyacinth, four studies, 2003, pencil drawing, 16.5 x 48 in.
Sensation and Behavior: Structure and Function, 1972, screen print, 11 x 7 in.

Ben Katchor
I.D. Tags from Julius Knipl, Real Estate Photographer, 1994, ink on paper, 11 x 17 in.

Yuri Kuper
Tulpan (Tulip), 2000, lithograph, 41.25 x 26.25 in. Courtesy of Pettibone Fine Art, New York

Ibram Lassaw
3 Shapes, 2001, ink on paper, 26 x 16.5 in.

Joanne Leonard
Four Generations, One Absent, 1992, gouache, gelatin silver print, 16 x 20 in.
Conversation: My Mother and Her Mother, 1992, gelatin silver print, 16 x 20 in.

JANE LOGEMANN
Kaddish, 1995,
ink, wash on linen, 39 x 29.75 in.
From the collection of
Dr. Norman J. Cohen

SUSAN MALLOY
Trees at Sunset, 2000, pencil on
paper drawing, 26 x 20 in.

MARGALIT MANNOR
*Revisiting the Unknown, Fading
Sight/Fading Memory,* 1997,
photograph, c-print,
24 x 24 in. each
Dark Fragment
Fragment
In Focus
Out of Focus

YEHUDIT MATZKEL
color print
Untitled, 1999, 40 x 60 in.
Untitled, 1999, 16 x 20 in.
Untitled, 1999, 16 x 20 in.

LEONARD MEISELMAN
Double Self Portrait, 2003,
oil on canvas, 60 x 36 in.

ALICIA MILOSZ
2003, lenticular prints,
24 x 24 in. each
Mom, Age 25 and 77
Dad, Age 25 and 77

NORMA MINKOWITZ
Box, 1993, mixed media object,
8.5 x 8 x 16 in.
Courtesy of Bellas Artes Gallery,
Santa Fe, NM

RUTH NEVO
A Glass of Wine, 1987,
oil on canvas, 18.5 x 14 in.
Sophy, 1987, 16 x 12 in.

NATAN NUCHI
Binding of Isaac, 1984, spray
enamel on canvas, 96 x 65 in.

MARK PODWAL
Three Studies of Ecclesiastes,
2003, acrylic, gouache, and
colored pencil on paper,
10 x 11.5 in. each
*Alas the Wise Man Dies Just like
the Fool*
*The Day of Death is Better than
the Day of Birth*
*And the Dust Returns to the
Ground*

PAUL PETER PORGES
ink on paper, 8.5 x 11 in. each
Alzheimer Echos of the Past
Old Money
The Three Ages of Women
Young Man/Senior citizen
Fairway, pencil on paper,
13.75 x 17 in.

DAVID RAPPAPORT
Nightfall, 2002,
acrylic on canvas,
16 x16 in.

HAVA RAUCHER
Eve, 1997, oil on canvas,
72 x 54 in.
Eve, 1999, oil on canvas,
76 x 44 in.

ELAINE REICHEK
Sampler (DNA), 2002,
embroidery on linen, 14.5 x 58 in.
Courtesy of Shoshanna Wayne
Gallery, Santa Monica, CA

DEBORAH ROSENTHAL
Gravestone of the Old Couple,
2002, oil, pastel on linen,
21 x 28 in.

BARBARA ROTHENBERG
Fern Unfurling, 1997,
sumi ink on paper, 12 x 15 in.

JANICE RUBIN
gelatin silver prints,
8.5 x 13 in. each
Family Exercise Class, 1982
Itka Tells an Emotional Story,
1986, *Poppie with Nick,* 1990
Uncle Miltie, 1984

JONATHAN SANTLOFER
mixed media on wood,
each work 80 x 96 in.
The Women' s Story,
1996-1997, triptych
The Men' s Story,
1996-1997, triptych

DEIDRE SCHERER
Two Women, 1998,
fabric and thread, 28 x 24 in.
Collection of the artist

RUTH SCHLOSS
Untitled, 1995, 13 x 16 in.
acrylic on paper
Untitled, 1995, 13 x 16 in.
acrylic on paper
Waiting, 1996, acrylic on canvas,
14 x 18 in.

IVAN SCHWEBEL
2 Samuel 12:15 on a Bronx Street,
1990, oil on canvas,
28 x 33 in.

GEORGE SEGAL
Helen V, 1996,
pastel on paper, 38 x 50 in.
Courtesy of the George and Helen
Segal Foundation, Carroll Janis,
Inc.

GIDEON SCHACKNAI
Changing, 1999, oil on canvas,
30 x 24 in.

LAURA LAZAR SIEGEL
To Life, 2003, acrylic on paper,
22 x 30 in.

ROBBIN AMI SILVERBERG
WITH **LOUISE MCCAGG**
Sisters: Five Smooth Stones,
1992-1993, mixed media,
22 x 22 x 28 in.

KIKI SMITH
etching 22 x 15 in. each
Fall, 1999
Winter, 1999
Courtesy of the Rutgers Center
for Innovative Print and Paper,
New Brunswick, NJ

JOAN SNYDER
Kaddish for Lilly, 1999,
oil, acrylic, papier maché
on canvas, 24 x 36 in.

ANN SPERRY
My Piano 22, 2003, wood,
metal, ivory, 39 x 24 x 24 in.
Courtesy of Kraushaar Gallery,
New York

ART SPIEGELMAN
Family Values, 1993,
The New Yorker cover

MELISSA STERN
Class, 2003, oil, encaustic,
mixed media, 27 x 30 in.
Courtesy of Lusk Gallery,
New York

MIRIAM STERN
Carousel, 1999,
oil on canvas,
48 x 60 in.

SERGEI TERYAEV
Golf, 1999, oil on canvas,
44 x 36 in. *Loneliness,* 1999,
oil on canvas, 44 x 36 in.

JONATHAN WAHL
Wisdom/Memory, 2003, metal,
height 20 x diameter 14 in.

JOYCE ELLEN WEINSTEIN
Behold, Thy Days Approach,
2003, mixed media, 18 x 13 in.

RUTH WEISBERG
Initiation, 1997, drawing on paper,
44 x 22 in.
Collection of Judith Resnick and
Dennis Curtis

ALLAN WINKLER
Old Man with Hat, 2003,
paper-cut, 24 x 18 in.

LAURIE WOHL
...Renewed like the Eagle's, 2003,
textile, mixed media,
64 x 60 in.

LLOYD WOLF
*Exercise Class, Madison Center,
Arlington, VA,* 2002,
photograph, 16 x 22 in.

DONALD WOODMAN
Yugoslavia, 1971,
photograph, 17 x 22 in.

ITZHAK YAMIN
Memories from Father's
oil on canvas
Home, 1993, 20 x 24 in.
oil on canvas
Tools from My Father's Home,
1997, 35 x 24 in.

BEBA YANNAY
Untitled, 1999, corrugated paper,
collage newsprint, tacks,
and paint 14.5 x 17 in.
Untitled, 1998, acrylic on canvas,
17 x 19 in.
Untitled, gouache on paper,
16.5 x 18.75 in.
Untitled, 1991, acrylic on canvas,
28 x 39 in.

BARBARA ZUCKER
Time Signatures: Golda Meir,
2002, laser-cut steel,
17.5 x 21.25 x 1.5 in.